Where's Elvis?

FIND HIM IN 20 PIECES OF ELVIS-INSPIRED ART

ANDREW GRANT JACKSON

ILLUSTRATIONS BY VICTOR BEUREN

THUNDER BAY
P·R·E·S·S
San Diego, California

For Keira: Follow that dream!

Thunder Bay Press
An imprint of Printers Row Publishing Group
10350 Barnes Canyon Road, Suite 100, San Diego, CA 92121
www.thunderbaybooks.com

Thunder Bay Press
Publisher: Peter Norton
Publishing Team: Lori Asbury, Ana Parker, Laura Vignale, Kathryn Chipinka
Editorial Team: JoAnn Padgett, Melinda Allman, Dan Mansfield
Production Team: Jonathan Lopes, Rusty von Dyl

This book was conceived, designed, and produced by
Quintet Publishing Limited
Ovest House,
58 West Street,
Brighton,
BN1 2RA
United Kingdom

Project Editor: Cheryl Brown
Designer: Allen Boe
Illustrators: Victor Beuren
Art Director: Michael Charles
Editorial Director: Emma Bastow
Publisher: Mark Searle

ISBN: 978-1-62686-676-8

Printed in China by Toppan Leefung

20 19 18 17 16 1 2 3 4 5

Picture Credits
Page 6: Alfred Wertheimer/Getty Images; page 12: RB/Redferns; page
16: Michael Ochs Archives/Getty Images; page 20: Michael Ochs
Archives/Getty Images; page 24: Charles Trainor/The LIFE Images
Collection/Getty Images; page 28: Michael Ochs Archives/Getty
Images; page 32: Michael Ochs Archives/Getty Images; page 36: Metro-
Goldwyn-Mayer/Getty Images; page 40: Bettmann; page 44: STF/AFP/
Getty Images; page 48: GAB Archive/Redferns; page 52: Michael Ochs
Archives/Getty Images; page 56: Liaison/Getty Images/Staff; page 60:
Ron Galella, Ltd./WireImage/Ron Galella/Contributor; page 64: Michael
Ochs Archives/Getty Images; page 68: Michael Ochs Archives/Getty
Images; page 72: MPI/Getty Images; page 76: GAB Archive/Redferns;
page 80: Michael Ochs Archives/Getty Images; page 84: Steve Morley/
Redferns; page 88: Fred Ross/Toronto Star via Getty Images.

Where's Elvis?

Contents

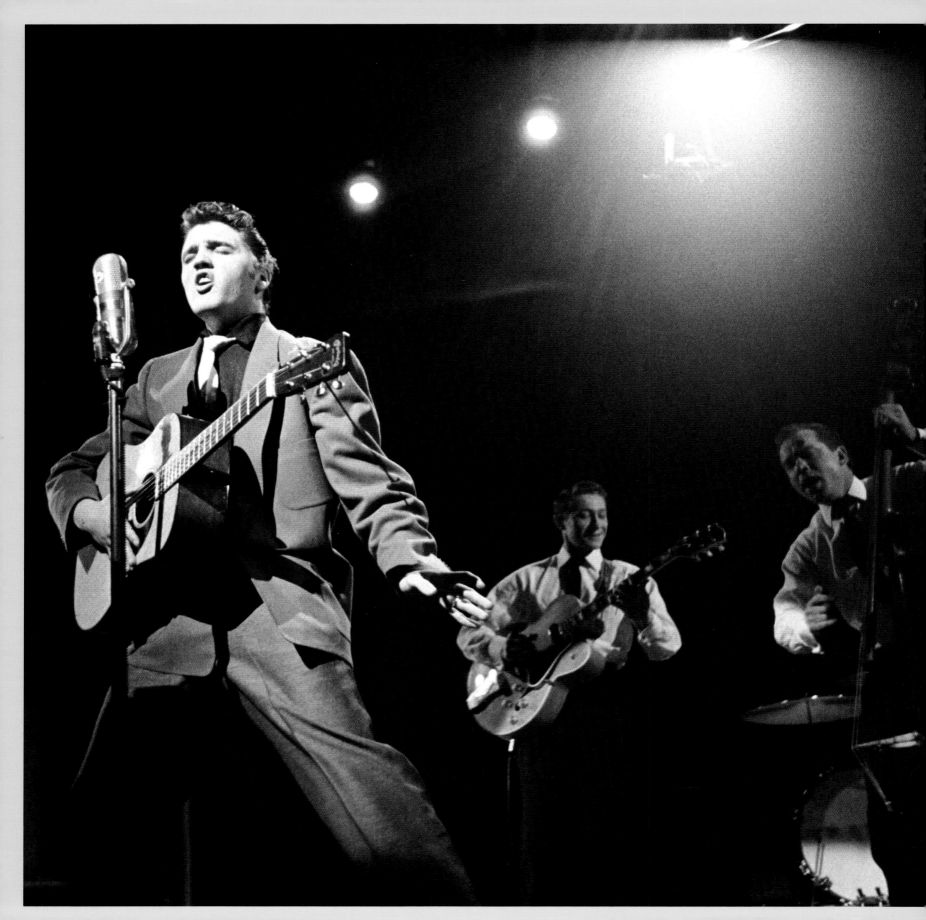

Where's Elvis?

Introduction

So many elements had to come together to create the Elvis Presley phenomenon that it seems miraculous it actually happened. You needed someone barely out of his teens with a powerful voice equally adept at explosive rockers and delicate ballads. Someone with a voracious appetite for all genres of music and the ability to synthesize them. Someone with movie-star looks, an outrageous sense of style, and the inability to stand still onstage. Someone who grew up next to a black community and was discovered by the producer of blues legends like Howlin' Wolf.

Sun Records' Sam Phillips was determined to bring R&B to a white audience, and together he and Elvis crystallized the rockabilly genre. U2's Bono said that "you had two cultures colliding there. You had a kind of white, European culture and an African culture coming together—the rhythm, okay, of black music and the melody chord progressions of white music—just all came together in that kind of spastic dance of his."

Hank Ballard, the African American singer of the original version of "The Twist," observed, "In white society, the movement of the butt, the shaking of the leg, all that was considered obscene. Now here's this white boy that's grinding and rolling his belly and shaking that notorious leg. I hadn't even seen the black dudes doing that."

Elvis's friend Jackie Wilson said, "A lot of people have accused Elvis of stealing the black man's music, when in fact, almost every black solo entertainer copied his stage mannerisms from Elvis."

According to biographer Peter Guralnick, Elvis's uninhibited dancing wasn't a problem in the South, but when he appeared on national television in 1956, where a Victorian conservatism still dominated, he incurred the wrath of ministers, politicians, and critics.

There was also the fact that Elvis inspired white kids to embrace black music in a country that was still segregated. Historian David Halberstam wrote that "the Supreme Court ruling on *Brown vs. Board of Education* [regarding the integration of schools] was the first important break between the older, more staid America that existed at the start of the era and the new, fast-paced, tumultuous America that saw the decade's end. The second was Elvis Presley. In cultural terms, his coming was nothing less than the start of a revolution."

Little Richard recalled, "When I came out they wasn't playing no black artists on no top 40 stations. I was the first. It took people like Elvis and Pat Boone and Gene Vincent to open the door. And I thank God for Elvis Presley, I thank the Lord for sending Elvis to open the door so I could walk down the road, you understand?"

Father of the rock industry

With the help of manager Colonel Tom Parker, Elvis expertly alternated his bad-boy image with that of a gospel-singing boy next door who loved his mama. On December 31, 1956, the front page of the *Wall Street Journal* announced that Presley merchandise had

Opposite: Elvis, guitarist Scotty Moore, and bassist Bill Black play live on the Dorsey Brothers' Stage Show TV program, March 17, 1956.

generated over $22 million over the past few months that year. Every label searched frantically for its own Elvis, and rock and roll bloomed into a market that dominated pop music for the next half century.

Crooner Tony Bennett explained, "The change was the big beat, and the volume went way up, and it just became a complete change of how to look at a performer. But you have to understand, Elvis was so terribly handsome and very sincere, he just had the thing that inspired all the young people that when they saw that, they said 'We want to emulate Elvis.'"

Even before Paul McCartney heard Elvis sing, he saw an ad for "Heartbreak Hotel" in a music magazine and was converted. "Elvis looked so great: 'That's him, that's him—the Messiah has arrived!'" When Elvis had been in high school, his pompadour made football players want to beat him up, but it became the archetype for nonconformists on both sides of the Atlantic. With his outrageous fashion sense, from gold lamé jackets to pink Cadillacs, he was, per designer Tommy Hilfiger, "the first white boy to really bling it up." And he had an instinctual genius for, as Madonna later put it, "striking a pose," an art without a name in postwar America, though in Japan it had been a part of kabuki and Noh theater for hundreds of years.

Roots music purists maintain Elvis's music went downhill after he left Sun Records in 1955, but it was only after that he added drums, backing vocals, and piano to his sound. In 1956 he released two groundbreaking albums and an additional five singles that changed the course of popular music. Having learned from Sam Phillips, he became his own producer, choosing his songs and their tempos, sometimes pressing himself and the band past 30 takes.

When he was drafted, he practiced arias by the operatic tenor Caruso during his free time, increasing his range to two and one-third octaves, and on returning to the States in 1960 he recorded "It's Now or Never." In the studio, he briefly despaired that he could not hit the notes, but kept pushing himself—and wound up with his biggest hit.

Artistic controversy

Rockers like the Beatles and Keith Richards revered Elvis for combining the rebellion of Marlon Brando and James Dean with countrified R&B. Then in the early 1960s, to their dismay, he morphed into a crooner from the era they thought he had just killed off—when he wasn't playing cartoony pop not far removed from the Monkees (who, like Elvis, got many of their songs from Brill Building songwriters).

Elvis was actually singing what he intended to before Phillips steered him toward the blues. As he told the *Charlotte Observer* in 1956, "I like to sing ballads the way Eddie Fisher does and the way Perry Como does. But the way I'm singing now is what makes the money. Would you change if you was me?"

Elvis expert Ernst Jorgensen said, "I don't think Elvis ever saw himself as a rock and roll or a country or an R&B or a ballad singer. He wanted to incorporate all these elements of American music into his own."

In the '90s, Generation X hipsters rediscovered lounge music and kitsch culture, and found a fascinating irony in the story of a country soul iconoclast who confounded his followers by plunging into an easy listening/bubblegum/show tune period. Four terrific albums can actually be culled from the 225 songs Elvis recorded for movie soundtracks: one collection of enduring theme songs, another two of deep-cut jewels, and one of camp curios. The soundtracks also rival the Beatles for pure eclecticism, featuring mariachi music, Dixieland, Hawaiian, Jamaican, German folk, even quasi-psychedelia ("Edge of Reality").

Some fans wish Elvis had just gone on hiatus after 1961 until his 1968 comeback special and not made any movies except *Viva Las Vegas* (1964). But for connoisseurs of pre-rock movie musicals or retro television programs, the widescreen Technicolor look of the films has aged well. Elvis briefly returned to a *Jailhouse Rock* edge in black

leather in 1964's *Roustabout*, helmed by John Rich, who had directed *Gunsmoke*, *Bonanza*, and *The Dick Van Dyke Show*. After the release of the Beatles' *A Hard Day's Night*, director Boris Sagal gave Elvis his own band to clown around with in 1965's *Girl Happy*.

"Rock-a-Hula Baby" wasn't a great song, but Elvis lit up the screen singing it with rainbow shakers in *Blue Hawaii*. *Speedway*'s campy "Let Yourself Go" scene vibrated like a Lichtenstein pop art comic book come to life, and inspired the diner in Quentin Tarantino's *Pulp Fiction*. When numbers like "A Little Less Conversation" are taken out of their films to stand alone, the high-gloss production values, sexy women, and sharp wardrobe reveal Elvis to be the ultimate video artist of all time. His best musical sequences would make a great DVD compilation if done in the manner of the Beatles' *1+* collection.

Elvis made at least seven fine movies: *Jailhouse Rock* (1957), *King Creole* (1958), *Flaming Star* (1960), *Wild in the Country* (1961), *Viva Las Vegas* (1964), *Elvis: That's the Way It Is* (1970), and *Elvis on Tour* (1972). But perhaps his film career's ultimate function was to make the 1968 TV special necessary. If he had not gone astray, he would not have howled for redemption in "If I Can Dream" with such ferocious desperation. As critic Greil Marcus wrote, it sounded like his life was at stake—indeed, his career was, and in that moment he saved it.

He channeled his newfound energy into the legendary sessions at American Sound Studio that produced "Suspicious Minds" and "In the Ghetto," then returned to the stage with a band that incorporated all the elements of his musical vision: musicians who could play rock and country, black female vocalists, male gospel singers, and a pop orchestra. Some of the best scenes in the 1970 documentary *Elvis: That's the Way It Is* show him directing the ensemble and arranging the numbers in rehearsal. All the while, he continued to strengthen his voice, taking it up three octaves for the climax of "What Now My Love" in 1973's *Aloha from Hawaii*

TV special. New songs reflected his split with Priscilla and regret at their broken home, and their adult sophistication counterbalanced the lighthearted movie period.

Epic discography

Elvis recorded approximately 711 songs, and released 24 studio albums, 19 soundtracks, and six live albums during his lifetime. Twelve are classics: *Elvis Presley* (1956), *Elvis* (1956), *Loving You* (1957), *Elvis Is Back!* (1960), *The Lost Album* (recorded 1963–64), *How Great Thou Art* (1966), *Elvis (NBC TV Special)* (1968), *From Elvis in Memphis* (1969), *Back in Memphis* (1969), *On Stage* (1970), *Elvis: That's the Way It Is* (1970), and *Elvis Country* (1971).

From 1956 to 1973 he recorded 24 to 50 songs a year (except in 1959), and for each of those years (except 1965) you can point to 12 fantastic tracks that would have formed an album to rival any by his competition. But Elvis and his manager came from an era before the Beatles and Bob Dylan turned the album into a work of art. Today, artists release one album loaded with singles every few years, but Elvis released two to four albums a year, plus additional singles. Sessions like his 1973 recordings at Stax Records, which could have been edited into one outstanding record, were spread into three LPs of middling quality.

Thus his discography was a mess until the 1990s, when Ernst Jorgensen and Roger Semon oversaw the compilation of three quintessential box sets, one for every decade of his career, along with separate soundtrack and gospel compilations. (Surprisingly, some of his most exuberant rockers are on his gospel records.)

The 20 chapters of *Where's Elvis?* tell the King's story from birth to his legacy today. In each picture, Elvis needs to be found, along with other important people and things from every phase in his career. There are pictorial keys at the end of the chapters to help you find details you might not have spotted.

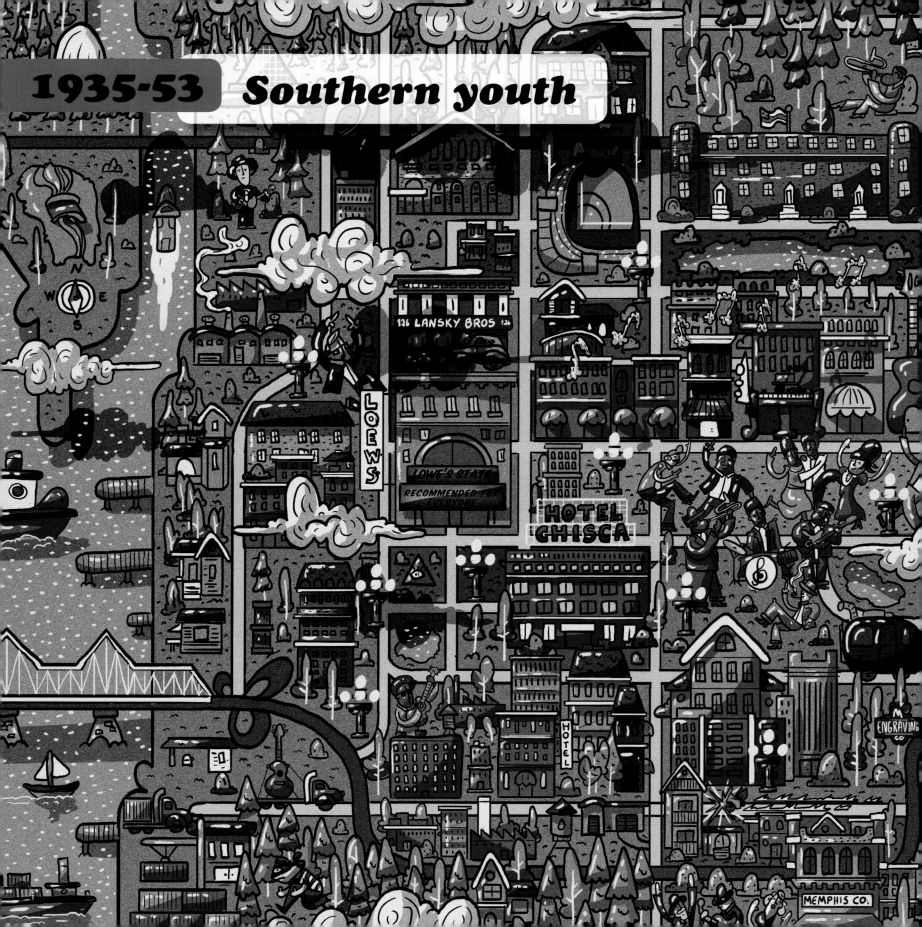

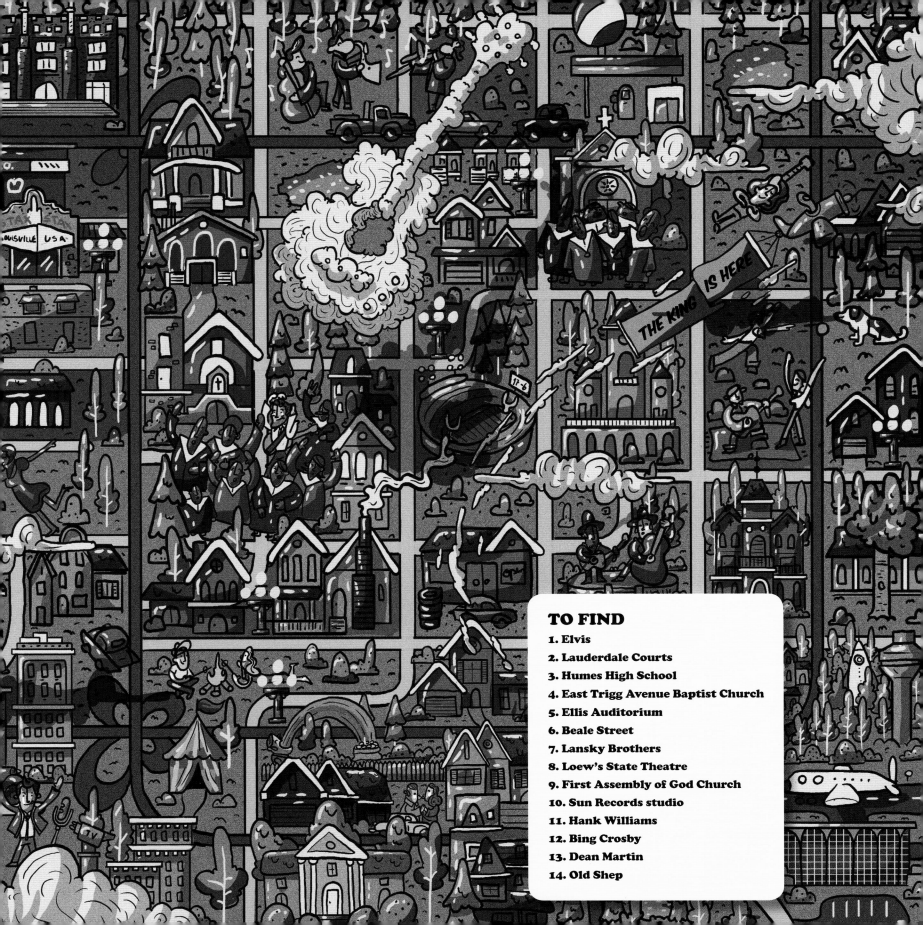

TO FIND

1. Elvis
2. Lauderdale Courts
3. Humes High School
4. East Trigg Avenue Baptist Church
5. Ellis Auditorium
6. Beale Street
7. Lansky Brothers
8. Loew's State Theatre
9. First Assembly of God Church
10. Sun Records studio
11. Hank Williams
12. Bing Crosby
13. Dean Martin
14. Old Shep

Southern youth

Above: Vernon, Elvis, and Gladys.

Elvis's mother, Gladys Presley, recalled how, when her two-year-old son was in church, "he would slide down off my lap, run into the aisle and scramble up to the platform. There he would stand looking at the choir and trying to sing with them."

Gladys had met her husband, Vernon, at the First Assembly of God Church in Tupelo, Mississippi, and took solace there in the difficult early years of their marriage. Elvis's twin brother Jessie Garon was stillborn, and when Elvis was three, Vernon was sent to the penitentiary for eight months for altering a check. The family lost their home and afterward needed government assistance for food.

Elvis told the Associated Press in 1956, "We used to go to these religious sing-ins all the time. There were these singers, perfectly fine singers, but nobody responded to 'em. Then there were these other singers—the leader was a preacher—and they cut up all over the place, jumpin' on the piano, movin' every which way. The audience liked 'em. I guess I learned from them singers."

Many of the South's greatest musical artists came out of the Pentecostal movement—B. B. King, Sister Rosetta Tharpe ("The Godmother of Rock and Roll"), Little Richard, Johnny Cash, Jerry Lee Lewis. In contrast to the more reserved Christian churches, the congregation sought direct communion with the Holy Spirit through rapturous singing, speaking in tongues, shouting, and shaking as if jolted by a high-voltage current—like Elvis onstage.

Elvis's favorite group was the white gospel quartet the Statesmen, who tossed the microphone to each other while their pianist, Hovie Lister, pounded out boogie-woogie with his hair in his face like a prototype Jerry

Lee Lewis. The bass singer, Jim "Big Chief" Wetherington, made the ladies scream by shaking his leg. Lead singer Jake Hess said, "He went about as far as you could go in gospel music. The women would jump up, just like they do for the pop shows."

By seventh grade, Elvis was bringing his guitar to school, slung over his back, and playing country songs at lunch. He was a quiet loner with a stutter and a bad case of acne, and some kids threw fruit at him or cut his guitar strings, but he kept at it.

DID YOU FIND?

1. Elvis

2. Lauderdale Courts
The Presleys lived in a two-bedroom apartment here from 1949 to 1953.

3. Humes High School
Elvis began attending eighth grade here when his family moved to Memphis in 1948, and he graduated in 1953.

4. East Trigg Avenue Baptist Church
Elvis attended this black church to hear Reverend W. H. Brewster and his choir sing, while people danced in the aisles. Brewster wrote songs like "How I Got Over," which Mahalia Jackson sang at the March on Washington with Martin Luther King Jr.

5. Ellis Auditorium
Elvis and his family attended the All-Night Gospel Singings here.

6. Beale Street
Memphis's African American entertainment district.

7. Lansky Brothers
Elvis bought his outrageously colorful clothing here.

8. Loew's State Theatre
Elvis served as an usher here.

9. First Assembly of God Church

10. Sun Records studio

11. Hank Williams
The country singer-songwriter got his start on the *Louisiana Hayride* radio show in 1948, like Elvis would in 1954. Elvis performed Williams's song "Kaw-Liga" in high school, and recorded "Your Cheatin' Heart," "I Can't Help It (If I'm Still in Love with You)," and "I'm So Lonesome I Could Cry."

12. Bing Crosby
Bing Crosby and Bob Hope's seven *Road* films combined exotic locations with musical comedy, as Elvis's films later would. Elvis covered "Blue Hawaii," "White Christmas," "Have I Told You Lately That I Love You," "True Love," "Harbor Lights," and "Beyond the Reef."

13. Dean Martin
"I've always been kind of partial to Dean Martin," Elvis said, and he covered "I Don't Care If the Sun Don't Shine." He did nine films with director Norman Taurog, who had previously made six films with Martin and Jerry Lewis.

14. Old Shep
At the Mississippi-Alabama Fair and Dairy Show on October 3, 1945, ten-year-old Elvis dressed up as a cowboy, stood on a chair in front of hundreds of people, sang Red Foley's "Old Shep" about a boy and his dog, and won fifth place. He recorded it on his second album.

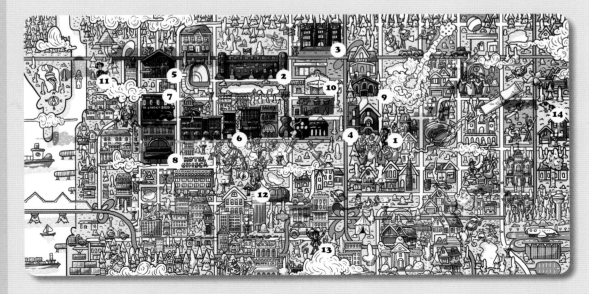

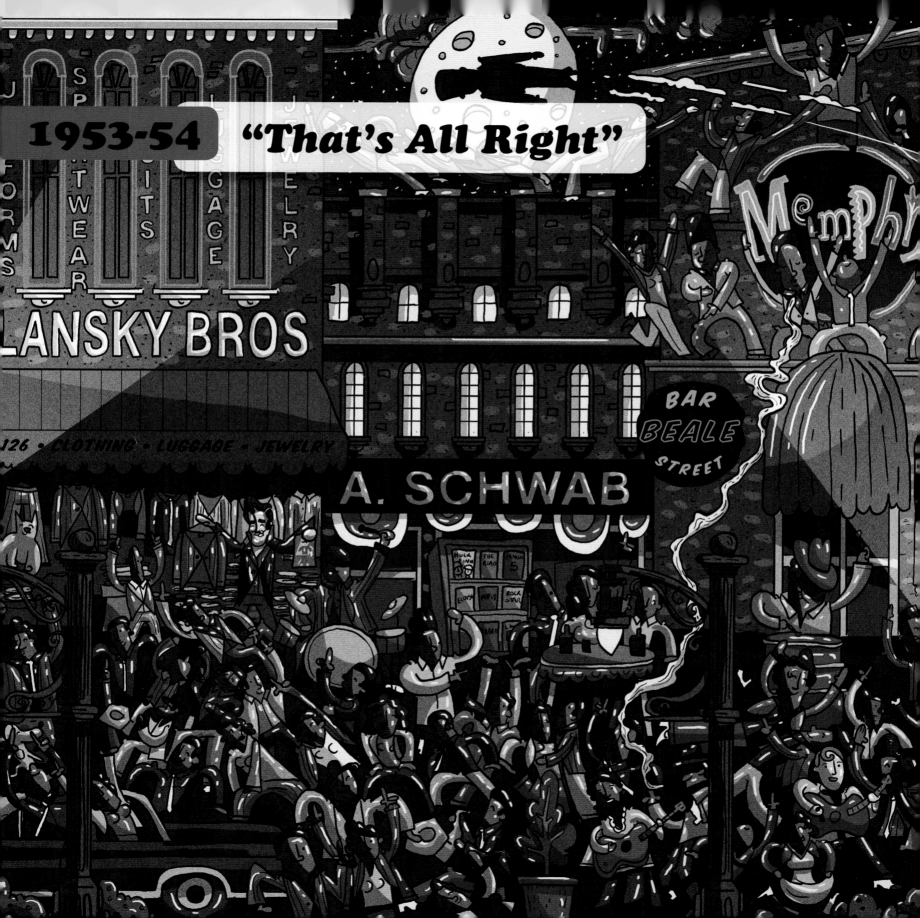

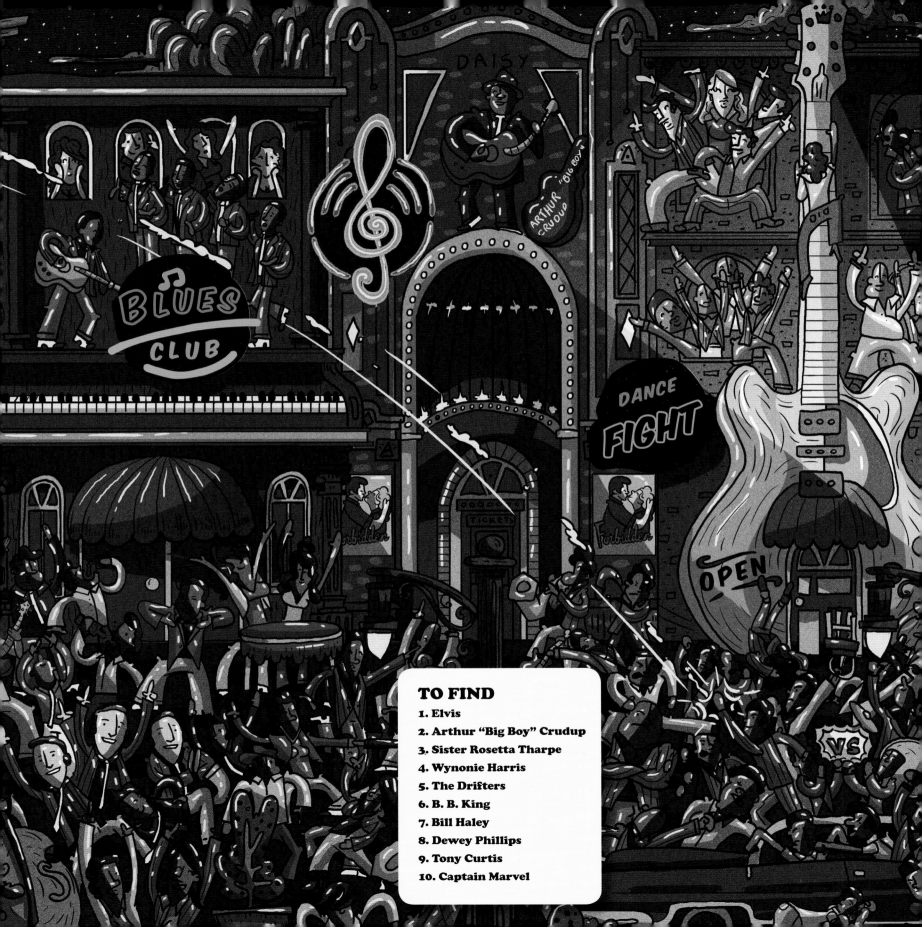

TO FIND
1. Elvis
2. Arthur "Big Boy" Crudup
3. Sister Rosetta Tharpe
4. Wynonie Harris
5. The Drifters
6. B. B. King
7. Bill Haley
8. Dewey Phillips
9. Tony Curtis
10. Captain Marvel

"That's All Right"

"The colored folks been singing it and playing it just like I'm doin' now, man, for more years than I know. They played it like that in the shanties and in their juke joints," Elvis told the _Charlotte Observer_ in June 1956.

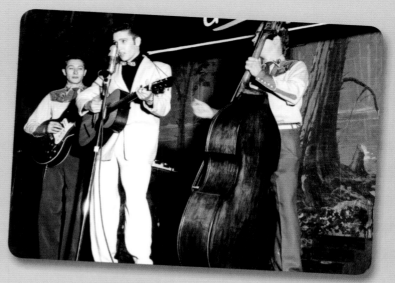

Above: Scotty, Elvis, and Bill perform on the Louisiana Hayride radio show on October 16, 1954.

"I got it from them. Down in Tupelo, Mississippi, I used to hear old [blues singer] Arthur Crudup bang his box the way I do now, and I said if I ever got to the place where I could feel all old Arthur felt, I'd be a music man like nobody ever saw."

In Tupelo, Elvis lived in a shack adjacent to the African American community called Shake Rag, and when he moved to Memphis he lived a mile away from Beale Street, the rollicking African American entertainment district filled with night clubs, theaters, and stores.

Beale not only fired his imagination musically—its fashion became an indelible part of his image. Lansky Brothers was the clothing shop where the locals bought their outfits for Saturday night. Elvis would buy a pink shirt and black pants with a pink stripe down the side, or a black shirt and pink pants with a white stripe, matched with a white tie and white shoes.

The summer he graduated high school, he learned there was a local studio owned by a fellow named Sam Phillips, who let anyone come in and make a record for $3.98, so Elvis came by and cut a few tracks. The white Phillips had grown up picking cotton alongside black workers, and loved their blues and spirituals, particularly the ones sung by a blind black sharecropper named Uncle Silas Payne, who lived with Sam's family. Sam produced blues artists like B. B. King and Howlin' Wolf.

But in an era of segregation before the civil rights movement, "there was something in many of those [white] youngsters that resisted buying this music," Phillips later told the _Memphis Press-Scimitar_. "They liked the music, but they weren't sure whether they ought to like it or not. So I got to thinking how many records you could sell if you could find white performers who could play and sing in this same exciting, alive way."

Elvis dropped by sporadically, and Phillips decided to put him together with 22-year-old guitarist Scotty Moore and 27-year-old bassist Bill Black. The trio rehearsed on July 4, 1954, then came in to Sun Records the next evening.

For the first few hours, they recorded ballads like Bing Crosby's "Harbor Lights," but nothing caught fire. Elvis's big break looked like a flop. They decided to take five.

To let off nervous energy, Elvis started strumming "That's All Right," a 1946 single by Arthur Crudup. Crudup had lifted the chorus from Blind Lemon Jefferson's 1926 blues song, "That Black Snake Moan." As Scotty Moore recalled to music historian Peter Guralnick, "All of a sudden, Elvis started singing this song, jumping around and acting the fool. Then Bill Black picked up his bass and began acting the fool too, and I started playing with them. Sam, I think, had the door to

the control booth open . . . he stuck his head out and said, 'What are you doing?' And we said, 'We don't know.' 'Well, back up,' he said, 'try to find a place to start, and do it again.'"

They listened to the playback, then refined it over a series of takes. The song blasted through the wall between country and R&B as if the wall wasn't even there. Moore and Black worried it was so different they might get "run out of town." Sam's assistant Marion Keisker later said, "I know that Elvis could not have walked into any other recording studio in the United States and have had that experience. It stands to me as absolutely the point at which our society was ready to change."

DID YOU FIND?

1. Elvis

2. Arthur "Big Boy" Crudup
"I wanted to be as good as Arthur Crudup when I saw him, back in '49," Elvis said of his fellow Mississippian. Aside from "That's All Right," Elvis recorded Crudup's "My Baby Left Me" and "So Glad You're Mine."

3. Sister Rosetta Tharpe
Elvis, Little Richard, Johnny Cash, and Jerry Lee Lewis were influenced by how she sang gospel while rocking on her guitar.

4. Wynonie Harris
After Harris topped the rhythm-and-blues chart in 1948 with "Good Rockin' Tonight," there was a flood of R&B songs with "rock" in the title. Many feel Elvis got some of his hip swinging, leg shaking, lip curling, and hand waving from him.

5. The Drifters
Elvis covered "Money Honey," "Such a Night," "White Christmas," and "Fools Fall in Love," and Clyde McPhatter's solo songs "Come What May" and "Without Love."

6. B. B. King
Riley King's initials stood for "Beale Street Blues Boy" shortened. "When I was in Memphis with my band, [Elvis] used to stand in the wings and watch us perform," the blues guitarist told *Sepia Magazine* in 1957. "He's been a shot in the arm to the business and all I can say is 'that's my man.'"

7. Bill Haley
The Detroit native might have created rockabilly in 1951 when his country band covered Sun's R&B hit "Rocket 88." Haley's "Crazy Man Crazy" was the first rock song to make the pop Top 20 in April 1953, followed by his cover of "Shake, Rattle, and Roll." In 1955 "Rock Around the Clock" became the first rock record to reach number one on the pop charts.

8. Dewey Phillips
When Memphis radio station WHBQ's hyperactive DJ invited Elvis to the studio for his first interview, the singer was shaking, so Dewey didn't tell him the mic was on. When Dewey told him afterward that their chat had been broadcast, "[Elvis] broke out in a cold sweat."

9. Tony Curtis
Most of Elvis's classmates sported buzz cuts, but in his junior year he combed his hair into a high pompadour modeled after this movie star's—then grew his sideburns extra long to look like a tough truck driver.

10. Captain Marvel
In Elvis's favorite comic book, young Billy Batson yelled "Shazam!" and a lightning bolt transformed him into a superhero. Elvis sometimes emulated Marvel's curly lock of hair over the forehead, and later made the lightning bolt his personal insignia.

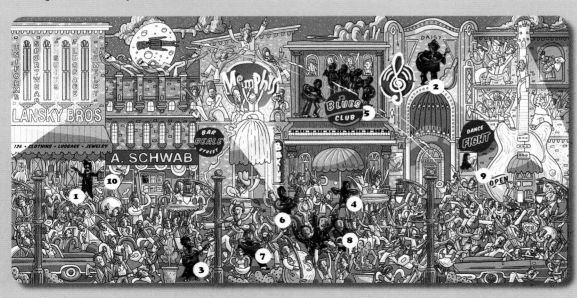

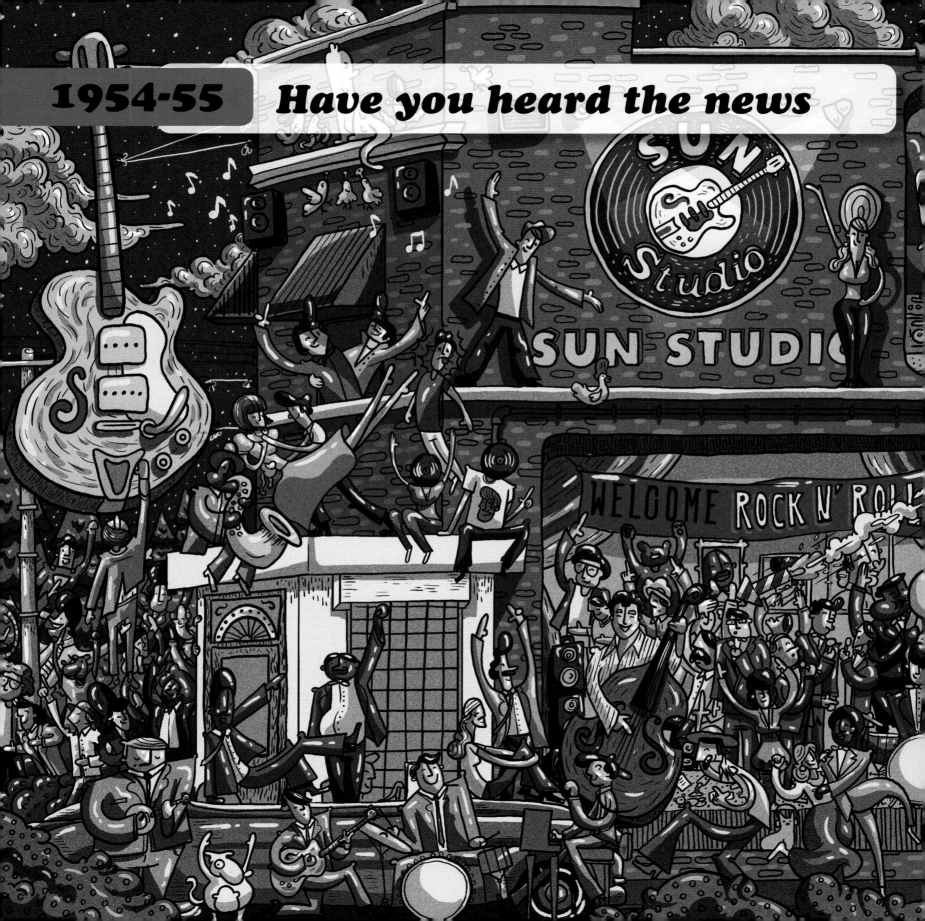

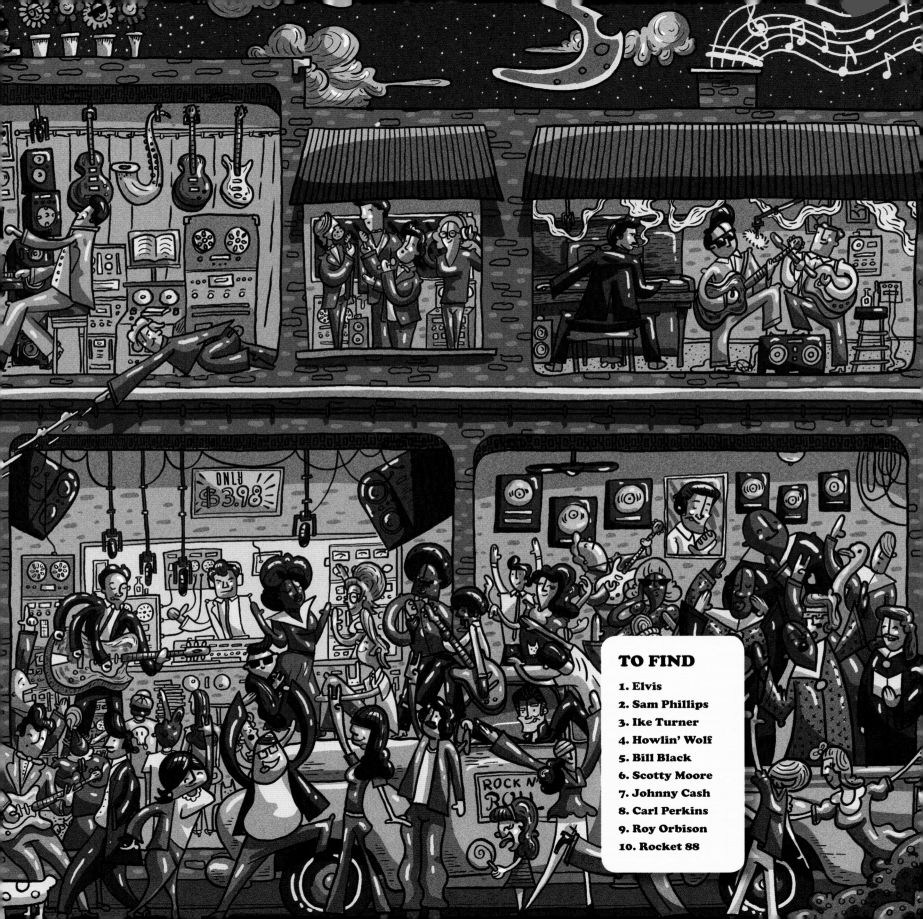

TO FIND

1. Elvis
2. Sam Phillips
3. Ike Turner
4. Howlin' Wolf
5. Bill Black
6. Scotty Moore
7. Johnny Cash
8. Carl Perkins
9. Roy Orbison
10. Rocket 88

Have you heard the news

When Elvis learned that Dewey Phillips was going to play "That's All Right" on his radio show, Elvis feared people were going to laugh at him, so he hid in a movie theater. But requests poured in to the DJ to play it again.

Above: Sam Phillips and Elvis, center, with journalists at Sun Records.

Dewey called Elvis's house and asked his folks to get their son down to the station, so they rushed and found him at the theater. Most people who heard "That's All Right" thought Elvis had to be black, so Dewey asked him where he went to school, as they were segregated then.

Now Elvis needed a B-side to put out the record, and returned to Sun Records. Scotty Moore recounted, "We're taking a little break and [Bill] starts beating on the bass and singing 'Blue Moon of Kentucky,' mocking [bluegrass artist] Bill Monroe, singing the high falsetto voice. Elvis joins in with him, starts playing and singing along with him."

The original was a slow waltz, but the boys sped it up to 4/4. Sam Phillips grinned and said, "That's fine, man. Hell, that's different. That's a pop song now, nearly 'bout." Phillips added "slapback" echo by recording the trio playing live on one tape recorder while another simultaneously played the sound back a few milliseconds later.

Elvis had his next eureka moment when they performed at the Overton Park Shell amphitheater on July 30, 1954. Battling a serious case of stage fright, Elvis jiggled his legs—and the girls in the audience

started shrieking. "I came offstage and [Scotty] told me they was hollering because I was wiggling my legs. I went back out for an encore, and I did a little more, and the more I did, the wilder they went."

Elvis's growing confidence was readily apparent in the next single, "Good Rockin' Tonight." It was another R&B song mutated into rockabilly when Moore replaced the horns and piano of the original with his country guitar twang. The biggest difference was it didn't have drums; none of Elvis's first three singles did. (The majority of country records in the mid-1950s didn't, having at most brushes on a snare, and drums were not even allowed onstage at Nashville's Grand Ole Opry.) Bill Black created the "click-clack" percussion sound (referred to as "slap bass") by plucking the heavy strings of his double bass and letting them slap back against the fingerboard.

Initially, country stations thought Elvis and the Blue Moon Boys (as they began billing themselves) were too R&B, and R&B stations thought they were too country. But after they secured a yearlong gig to appear on the *Louisiana Hayride* national radio show, "Baby Let's Play

House" made it to number five on the country chart and "I Forgot to Remember to Forget" topped it.

Sam did not have the record-pressing facilities to meet the growing demand for Elvis products, so he sold his contract to RCA Records.

Their final B-side together, "Mystery Train," embodied the wild ride Elvis's life had become as unprecedented fame rushed toward him. "At the end, Elvis was laughing, because he didn't think it was a take," Sam said, but "it was the greatest thing I ever did on Elvis."

DID YOU FIND?

1. Elvis

2. Sam Phillips
He licensed "Rocket 88" and other tracks to a Chicago label named Chess, which grew into the center of electric blues.

3. Ike Turner
After Ike played piano for B. B. King, King recommended Ike's band, the Kings of Rhythm, to Sam Phillips. When Anna Mae Bullock joined the band and married Ike, she took Tina Turner as her new name.

4. Howlin' Wolf
Sam Phillips heard the 41-year-old Chester Arthur Burnett's radio show in 1951 and invited him to make records. Sam called the Wolf his favorite artist, and was sad when he left for Chess to record classics later covered by the Rolling Stones, the Yardbirds, the Doors, Cream, and Led Zeppelin.

5. Bill Black
Bill galvanized the crowd by riding his bass, beating its sides, and whooping. Check out the band's April 1956 performance of "Blue Suede Shoes" on *The Milton Berle Show* to see him in action.

6. Scotty Moore
Scotty wanted to be a Nashville guitarist like Chet Atkins, but when he blended country thumb picking with the blues, he became one of the foremost architects of rock and roll. Keith Richards said, "Everyone else wanted to be Elvis. I wanted to be Scotty." So did Led Zeppelin's Jimmy Page.

7. Johnny Cash
Cash was discharged from the U.S. Air Force on July 3, 1954, two days before Elvis recorded "That's All Right." He moved to Memphis to live by his brother, then waited by the front door of Sun Records to get an audition.

8. Carl Perkins
Perkins was playing his own country/R&B fusion in Tennessee when he heard "Blue Moon of Kentucky" on the radio. "There's a man in Memphis that understands what we're doing," he told his wife, and journeyed to Sun Records to get signed. When Johnny Cash told him about a guy in the U.S. Air Force who called his military shoes "blue suede," Perkins wrote one of rockabilly's greatest anthems.

9. Roy Orbison
When Johnny Cash appeared on Roy's Texas TV show, he gave him Sam Phillips's number. Jerry Lee Lewis loaned Orbison some money to get to Sun Records. "Listen to those high notes. Nobody else can do that," Elvis said of the singer-songwriter. "Roy takes it high and sings it stronger than he does in his natural voice. And keeps it clear. Clear as a bell."

10. Rocket 88
When the Kings of Rhythm arrived at Sun Records to record "Rocket 88" (about the singer's car) in March 1951, guitarist Willie Kizart's amplifier was damaged, creating a fuzz distortion effect. But Sam Phillips liked the sound. The song topped the R&B charts, Bill Haley covered it, and many consider it the first rock record.

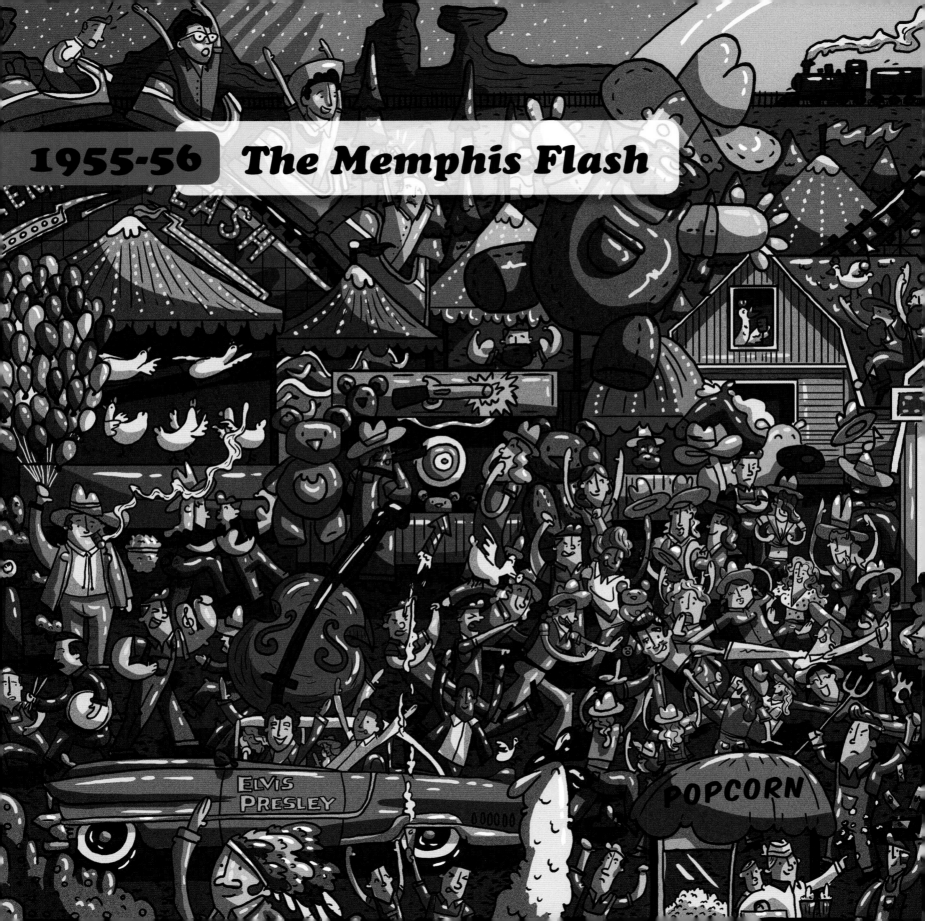

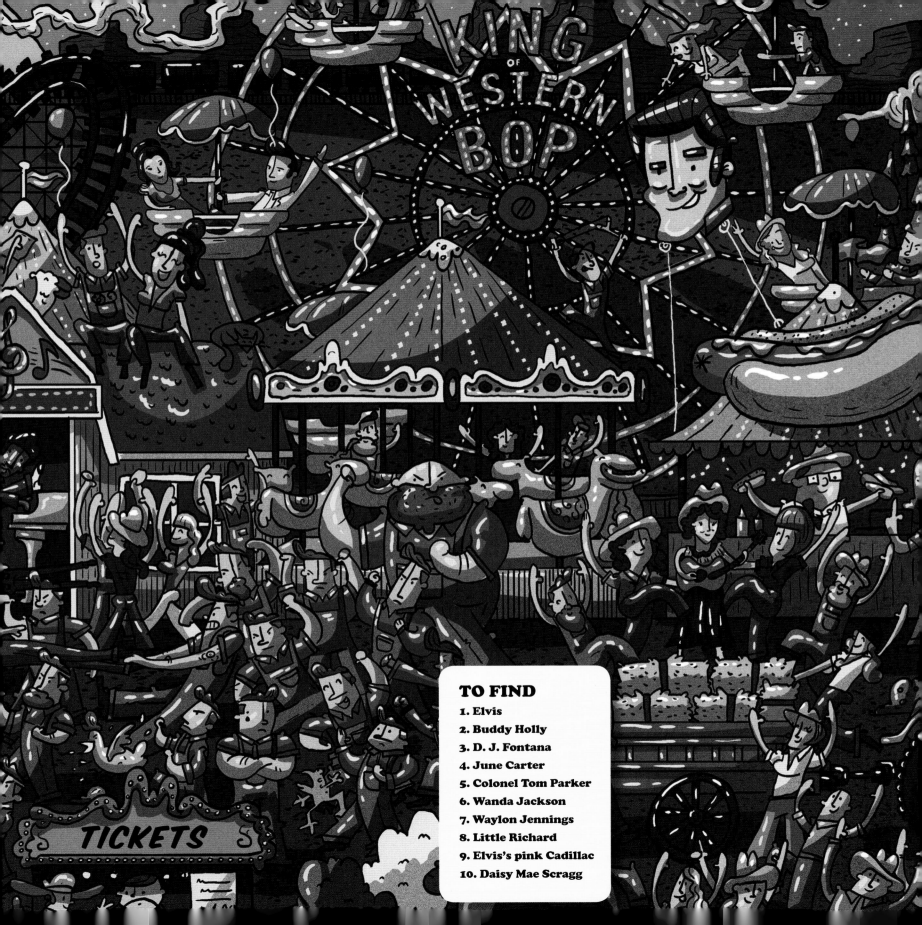

TO FIND

1. Elvis
2. Buddy Holly
3. D. J. Fontana
4. June Carter
5. Colonel Tom Parker
6. Wanda Jackson
7. Waylon Jennings
8. Little Richard
9. Elvis's pink Cadillac
10. Daisy Mae Scragg

The Memphis Flash

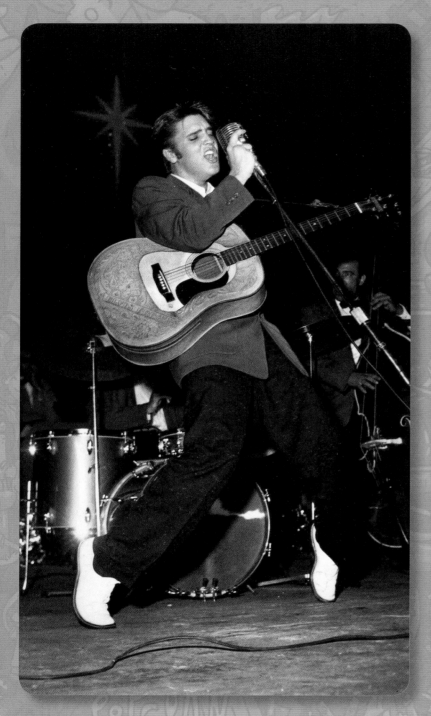

Above: Elvis and the band toured every month from October 1954 to November 1956.

Throughout the day, Elvis was always jittery, tapping his foot, and when he finally hit the stage, he said it was "like a surge of electricity going through you." Whenever a new shimmy or swivel brought screams, he added it to his arsenal of poses.

Two years earlier, he had told his prom date that he didn't know how to dance. Now, as historian Joel Williamson observed, Elvis let his female audience teach him what worked. He also deployed makeup and fashion to thrill the girls and confuse (or enrage) the boys, the same way glam rockers and New Wavers would do decades later, wearing a pink suit and royal-blue mascara. As writer Sigrid Arnott summarized, "Elvis was a white boy wearing black cat clothes in women's colors with eye makeup and hick sideburns."

"I can't overemphasize how shocking he looked and seemed to me that night," Roy Orbison later said about the first time he saw "the Hillbilly Cat" in Texas, when Roy was 19. "Actually it affected me exactly the same way as when I first saw that David Lynch film [*Blue Velvet*]. I just didn't know what to make of it. There was just no reference point in the culture to compare it."

Elvis arrived at RCA's Nashville studio on January 10, 1956, ready to take his Sun sound to the next level. Drummer D. J. Fontana and pianist Floyd Cramer were both members of the *Louisiana Hayride* house band and now would work with Elvis through 1968, along with the vocal group the Jordanaires. The coordinator of the Nashville studio was Scotty Moore's idol, guitarist Chet Atkins. Elvis felt he had to act out a song to cut it, so they surrounded him with three mics that could pick up his voice and guitar wherever he moved.

Elvis certainly wasn't playing it safe for his big label debut. The dark "Heartbreak Hotel" was unlike anything he had recorded at Sam Phillips's studio, except perhaps the ghostly "Blue Moon," and RCA executives wondered if they should have signed Carl Perkins instead. Perkins's "Blue Suede Shoes" had just become the first single to make the Top 5 on all three charts: pop, country, and R&B. But after Elvis made his first TV appearance on the Dorsey Brothers' *Stage Show* on January 28, "Heartbreak Hotel" streaked toward number one in pop, two in country, and three in R&B. The new age of rock had kicked down the door.

DID YOU FIND?

1. Elvis

2. Buddy Holly
Elvis transformed his stuttering problem into a hiccupping style influenced by hillbilly yodeler Jimmie Rodgers in songs like "Baby Let's Play House," inspiring Charles Hardin Holly, who opened for Elvis three times in 1955.

3. D. J. Fontana
Elvis appreciated D.J.'s experience playing for burlesque dancers, which taught him how to follow the singer's moves and punctuate them with his kit. He transformed the R&B shuffle into rock's slamming backbeat, and was a favorite of later drummers like Keith Moon.

4. June Carter
A member of the folk-singing Carter Family, she toured with Elvis in 1956. He sang Johnny Cash's songs for her so often that when Cash introduced himself to her, she said she knew him already—"I've had to listen to you enough." She and Cash married in 1968.

5. Colonel Tom Parker
Though he kept it secret until the 1980s, Andreas Cornelis van Kuijk was born in the Netherlands in 1909, entered the U.S. as an illegal immigrant, enlisted in the U.S. Army in 1929, went AWOL in 1933, spent two months in the army mental hospital, and was discharged for psychosis. He reinvented himself as the manager of Eddy Arnold and Hank Snow before taking the reins of Elvis's career in 1955. "Colonel" was an honorary title from Louisiana governor Jimmy B. Davis.

6. Wanda Jackson
Elvis told her there were plenty of female country singers but no women rockers. He taught her how to sing the records in his R&B collection, and she became the Queen of Rockabilly, covering his song "Let's Have a Party."

7. Waylon Jennings
He heard about Elvis's red pants, orange sports coat, and white shoes before he actually saw the "King of Hillbilly Bop" in concert. He played bass for Buddy Holly before becoming one of the leaders of outlaw country. Elvis covered his song "You Asked Me To."

8. Little Richard
Elvis covered four of his songs in 1956: "Tutti Frutti," "Rip It Up," "Ready Teddy," and "Long Tall Sally." Richard invited Elvis over, and the pair played songs on his piano for a few hours.

9. Elvis's pink Cadillac
Elvis added a lyric to "Baby Let's Play House" about a pink Cadillac and then bought one to tour in. It caught fire, so Elvis bought another, and Scotty Moore crashed it. Elvis fixed it, gave it to his mother, and it's still at Graceland today.

10. Daisy Mae Scragg
She pursued the hero of the comic strip *Li'l Abner*. Elvis turned down the lead role in the movie version, but it inspired his film *Kissin' Cousins*.

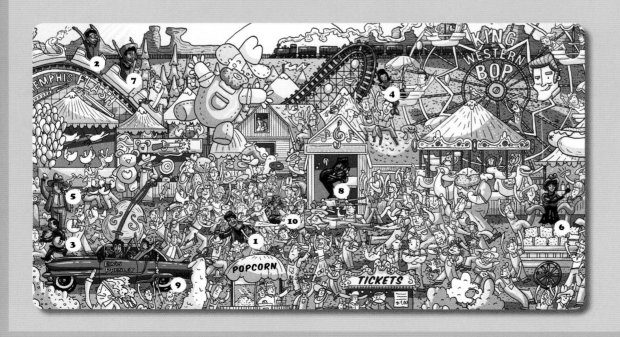

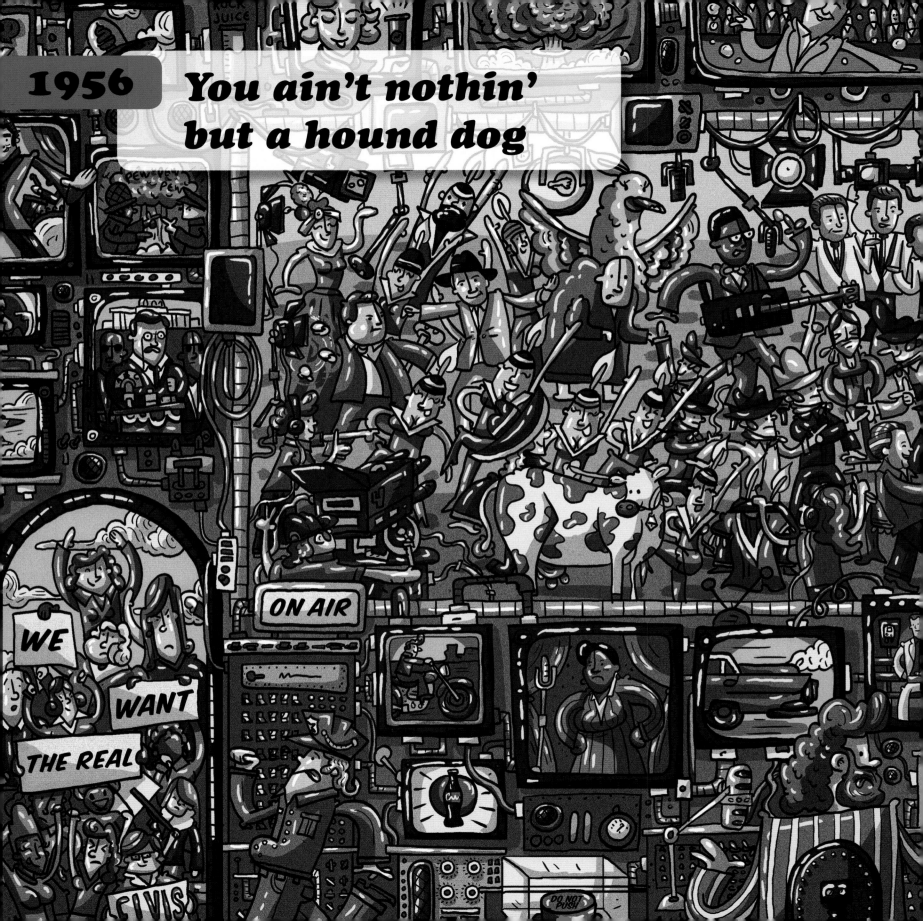

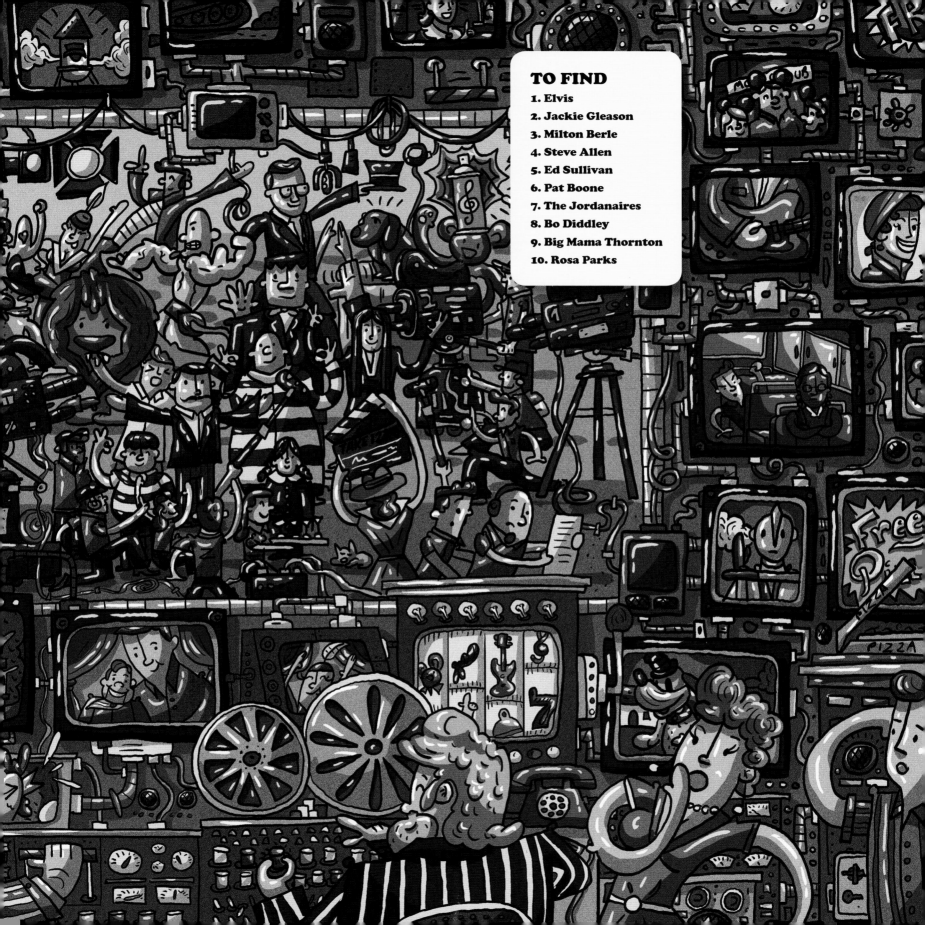

TO FIND
1. Elvis
2. Jackie Gleason
3. Milton Berle
4. Steve Allen
5. Ed Sullivan
6. Pat Boone
7. The Jordanaires
8. Bo Diddley
9. Big Mama Thornton
10. Rosa Parks

You ain't nothin' but a hound dog

In Kansas City, the band only played for 20 minutes before a new song in their set, "Hound Dog," provoked the frenzied crowd to smash through the police guards and onto the stage. Elvis bolted through the back door while the kids destroyed Bill Black and D. J. Fontana's instruments.

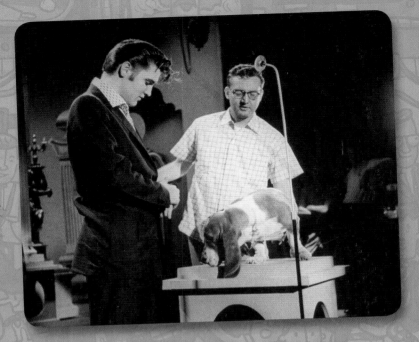

Above: Elvis and TV host Steve Allen rehearse on July 1, 1956.

The Wisconsin Catholic newspaper the *La Crosse Register* sent a letter to FBI director J. Edgar Hoover, warning that "Presley is a definite danger to the security of the United States," as his motions aroused the "passions of teenaged youth."

Television's beloved "Uncle Miltie" did little to quell such passions when he encouraged Elvis to perform without his guitar on his second appearance on *The Milton Berle Show* on June 5. "Let 'em see you, son." Midway into "Hound Dog," Elvis whipped his arm back and the band cut to half-time. As D.J. lay down his burlesque beat, Elvis exploded with his most provocative performance yet.

The day after this TV performance, the national media went ballistic. The *Journal-American* berated him for the "display of primitive physical movement difficult to describe in terms suitable to a family newspaper." The *New York Daily News* opined that pop music "has reached its lowest depths" with the rise of the "vulgar" Presley. Branded "Elvis the Pelvis," the singer shot back that the phrase was "one of the most childish expressions I ever heard, comin' from an adult."

Forty million people had tuned in, a quarter of the television-viewing audience, so *The Steve Allen Show* quickly booked him, though Allen assured the press, "He will not be allowed any of his offensive tactics."

Elvis told reporters, "I'm holding down on this show. I don't want to do anything to make people dislike me. I think TV is important so I'm going to go along, but I won't be able to give the kind of show I do in a personal appearance."

Allen had Elvis sing to a basset hound in a top hat on a footstool. Wearing a tux, Elvis tried to simultaneously play ball and mock the situation with his trademark sneer, but it was an awkward moment.

The next day, Elvis and the band felt a bit angry and humiliated. They headed over to RCA (whose mascot was another dog, Nipper) to cut "Hound Dog" for their next single. In front of the studio, Elvis's fans carried signs reading "We want the real Elvis, not the one on Steve Allen" and "We want the gyratin' Elvis."

With the kids outside the window, Elvis ripped into the song, channeling his fury at Steve Allen and the press calling him a dirty

white trash hillbilly. D.J. machine-gunned the snare and the Jordanaires soared over Scotty Moore's scorching twang. Elvis called for 31 takes before deciding they'd got it right.

Two days later, on July 4, he played a concert in his hometown of Memphis. "You know, those people in New York are not gonna change me none. I'm gonna show you what the real Elvis is like tonight."

Moore recalled, "He'd start out, 'You ain't nothin' but a—' and they'd just go to pieces. They'd always react the same way. There'd be a riot every time."

DID YOU FIND?

1. Elvis

2. Jackie Gleason
The Honeymooners star produced the Dorsey Brothers' *Stage Show*, on which Elvis appeared six times between January 28 and March 17, 1956. The TV executives did not want Elvis to shake so wildly on songs like "Flip, Flop, and Fly," but Elvis insisted it was the way he had to do it.

3. Milton Berle
After Elvis sang "Hound Dog," "Mr. Television" beamed, "How 'bout my boy! I love him!" and danced with Elvis. Berle said he knew Elvis was a star when the singer got 400,000 letters of hate mail.

4. Steve Allen
The original *Tonight Show* host was more sympathetic to beatniks than rockers, accompanying Jack Kerouac on piano as the author read from *On the Road*.

5. Ed Sullivan
He declared Elvis "unfit for family viewing," but when Elvis helped Steve Allen beat him in the ratings for the first time, Sullivan shelled out $50,000 to Elvis for three appearances, the highest amount ever paid to a TV performer to date. "As for his gyrations, the whole thing can be controlled with camera shots."

6. Pat Boone
Boone covered Little Richard and Fats Domino like Elvis, but he was the wholesome alternative to the Memphis bad boy.

7. The Jordanaires
The Grand Ole Opry regulars were the first white barbershop quartet to sing black spirituals, according to tenor Gordon Stoker. From 1956 to 1969, they backed Elvis on 361 songs.

8. Bo Diddley
Ellas Otha Bates stumbled upon his distinctive Afro-Cuban clave beat when he tried to cover country singer Gene Autry's "(I've Got Spurs) That Jingle Jangle Jingle." Elvis used it for "(Marie's the Name) His Latest Flame."

9. Big Mama Thornton
The 350-pound singer topped the R&B charts in 1952 with "Hound Dog," written for her by future Elvis composers Jerry Leiber and Mike Stoller. When Elvis performed a two-week engagement in Las Vegas in spring 1956, he heard a Bill Haley–styled band named Freddie Bell and the Bellboys cover the song and added it to his own set.

10. Rosa Parks
When she refused to move to the back of the bus, she sparked the Montgomery Bus Boycott, which marked the emergence of civil rights leader Martin Luther King Jr. Two days after she took her stand on December 1, 1955, Elvis played a concert in Montgomery, Alabama.

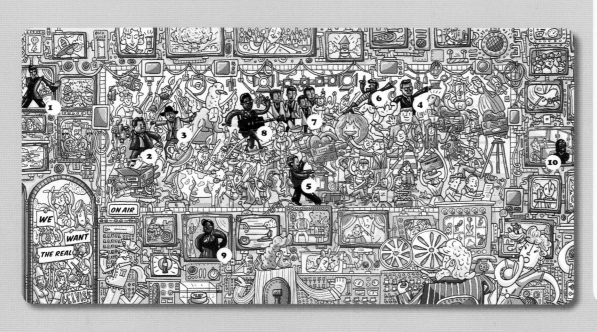

Elvis conquers America

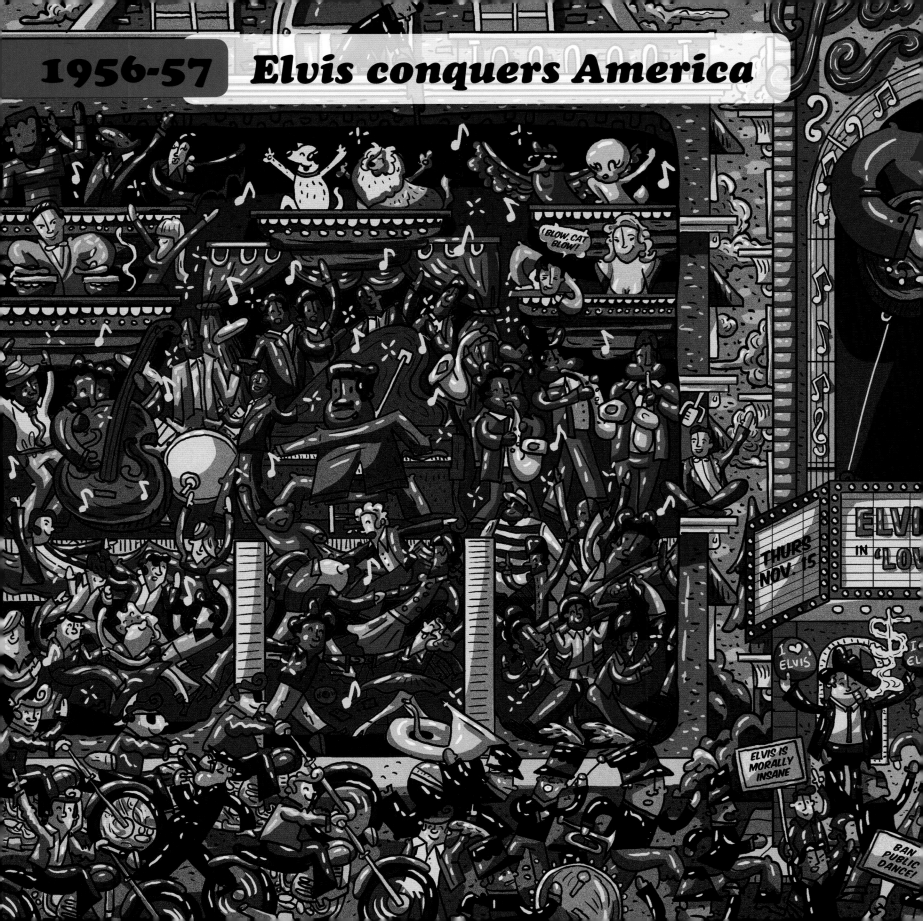

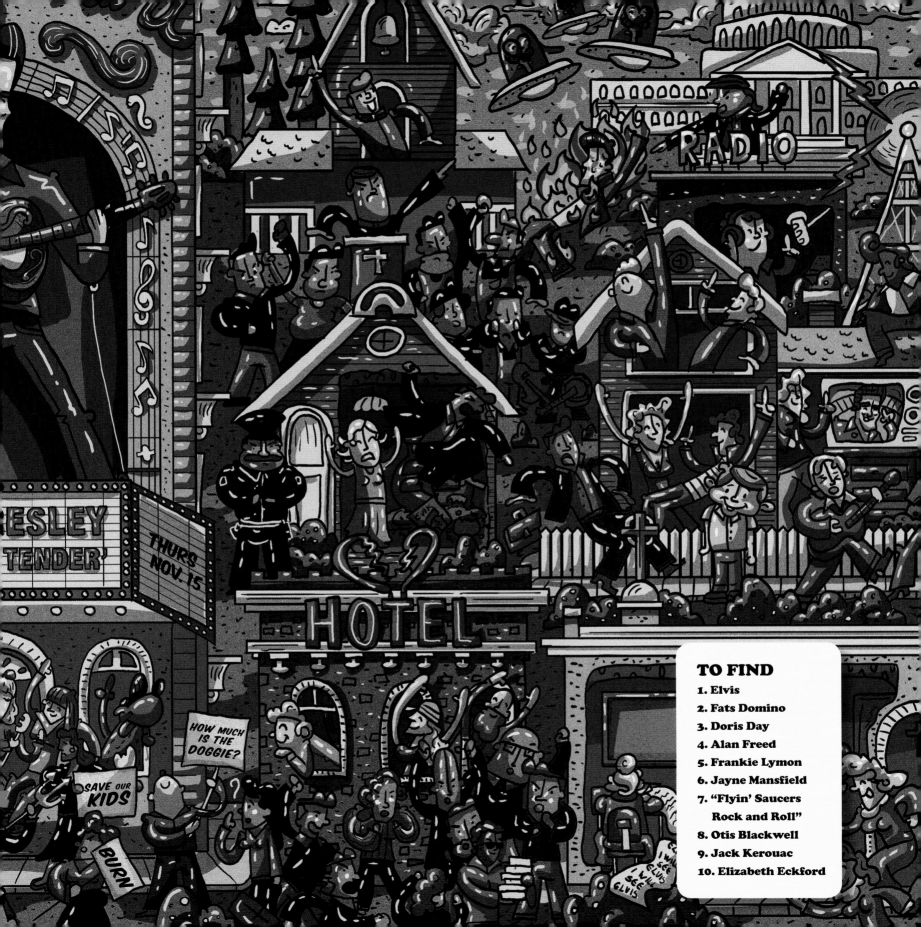

TO FIND
1. Elvis
2. Fats Domino
3. Doris Day
4. Alan Freed
5. Frankie Lymon
6. Jayne Mansfield
7. "Flyin' Saucers Rock and Roll"
8. Otis Blackwell
9. Jack Kerouac
10. Elizabeth Eckford

Elvis conquers America

After the band finished recording "Hound Dog," Elvis needed a flipside, so he listened to the pile of demos submitted for his consideration and picked one by songwriter Otis Blackwell called "Don't Be Cruel."

Scotty came up with the opening riff, D.J. beat on Elvis's guitar, and Elvis hiccupped and hummed, backed by the Jordanaires' incomparable harmonies. The song was as warm and funny as "Hound Dog" was aggressive, and the double-sided hit became the first single to top all three charts: pop, country, and R&B. It held the number one pop slot for 11 weeks, a record that stood for the next 36 years.

For Elvis's first appearance on *The Ed Sullivan Show*, September 9, 1956, 60 million tuned in—over 82 percent of the U.S. viewing audience. He premiered the theme song to his upcoming film debut, *Love Me Tender*, a tune based on the Civil War ballad "Aura Lee." It took over from "Don't Be Cruel/Hound Dog" in October, allowing him to hold the top position for 16 weeks, a record until Boyz II Men tied it in 1994, and Usher beat it in 2004.

Elvis also became the first artist to release two No. 1 albums in the same year. The first, *Elvis Presley*, opened with rock's shot from the bow, "Blue Suede Shoes." Five of the LP's 12 tracks were songs that had been recorded at Sun Records over the last year and a half but not released. The eerie wail of "Blue Moon" hinted that Elvis had absorbed Howlin' Wolf's "Moanin' at Midnight." (Sam Phillips considered Wolf's song one of the finest records he ever produced.) Since the Sun material sounded mostly country, Elvis balanced

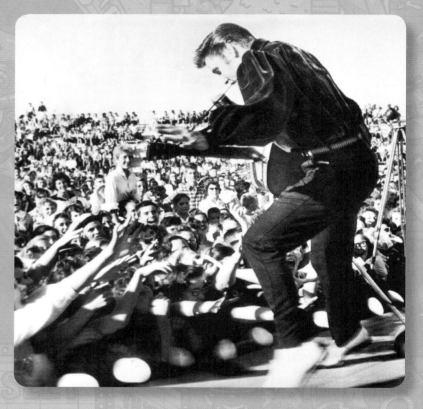

Above: Elvis plays the Mississippi-Alabama Fair and Dairy Show in his hometown of Tupelo on September 26, 1956.

the record out with R&B songs originally by Little Richard, Ray Charles, and the Drifters. The label submitted "One Sided Love Affair" to him, and it was his favorite song on the album after he goosed it up with an array of bouncy gospel inflections, the kind he'd return to in later tracks like "Joshua Fit the Battle."

The cover of *Elvis Presley* stands as one of his most iconic, with its pink and green lettering and the black-and-white photo of Elvis flailing at his acoustic with abandon. (The Clash emulated it for *London Calling* in 1979.) The image of Elvis rocking out helped turn the guitar into music's central instrument for a new generation of young people. Paul McCartney said, "I still love [it] the best of all

his records. It was so fantastic we played it endlessly and tried to learn it all. Everything we did was based on that album."

The second hit album, *Elvis*, launched with Little Richard's "Rip It Up," a manifesto for all the cats blowing their hard-earned cash Saturday night at the union hall. The writers of "Hound Dog," Jerry Leiber and Mike Stoller, contributed the concert fave "Love Me."

Blackwell nearly matched "Don't Be Cruel" with another infectious paean to impending matrimony, "Paralyzed." Also featured were cuts by the artists of Elvis's very first single, Arthur Crudup ("So Glad You're Mine") and Bill Monroe ("When My Blue Moon Turns to Gold Again"), both infused with the euphoria of Elvis's breakthrough year.

DID YOU FIND?

1. Elvis

2. Fats Domino
Elvis called the New Orleans pianist "one of my influences from way back." His hits included "Ain't That a Shame," "I'm Walking," "I'm Ready," and "Blueberry Hill," the second best-selling single of 1956.

3. Doris Day
When the singer/actress sang "Que Sera, Sera (Whatever Will Be, Will Be)" in Alfred Hitchcock's *The Man Who Knew Too Much*, the song became the biggest hit of 1956.

4. Alan Freed
After the Cleveland DJ noticed white teens were buying black records in 1951, he began playing them on his radio show *The Moondog House*, and helped popularize the term "rock and roll." He staged concerts that featured both black and white groups and integrated audiences, and appeared in movies like *Don't Knock the Rock*.

5. Frankie Lymon
The 13-year-old led his New York doo-wop group, the Teenagers, to the top of the UK and U.S. R&B charts with "Why Do Fools Fall in Love."

6. Jayne Mansfield
One of Marilyn Monroe's biggest rivals, the bombshell starred in the 1956 feature *The Girl Can't Help It* alongside Fats Domino, Little Richard, Gene Vincent, and the Platters.

7. "Flyin' Saucers Rock and Roll"
Sun Records released this rockabilly classic by Billy Lee Riley and His Little Green Men in February 1957, backed by Jerry Lee Lewis on piano.

8. Otis Blackwell
The writer of classics such as "Don't Be Cruel," "All Shook Up," and "Return to Sender," he was in one sense Elvis's mirror image: a black man who preferred country after growing up watching singing cowboys like Tex Ritter.

9. Jack Kerouac
Just as Elvis inspired rebellion through music, Kerouac did so with novels such as 1957's *On the Road*. Also like Elvis, Kerouac lost a brother, was extremely close with his mother, and was very patriotic.

10. Elizabeth Eckford
When the Supreme Court ordered the South to desegregate its high schools, federal troops had to protect 16-year-old Elizabeth and eight fellow students as they bravely faced down a racist mob to attend Central High School in Little Rock, Arkansas, in September 1957.

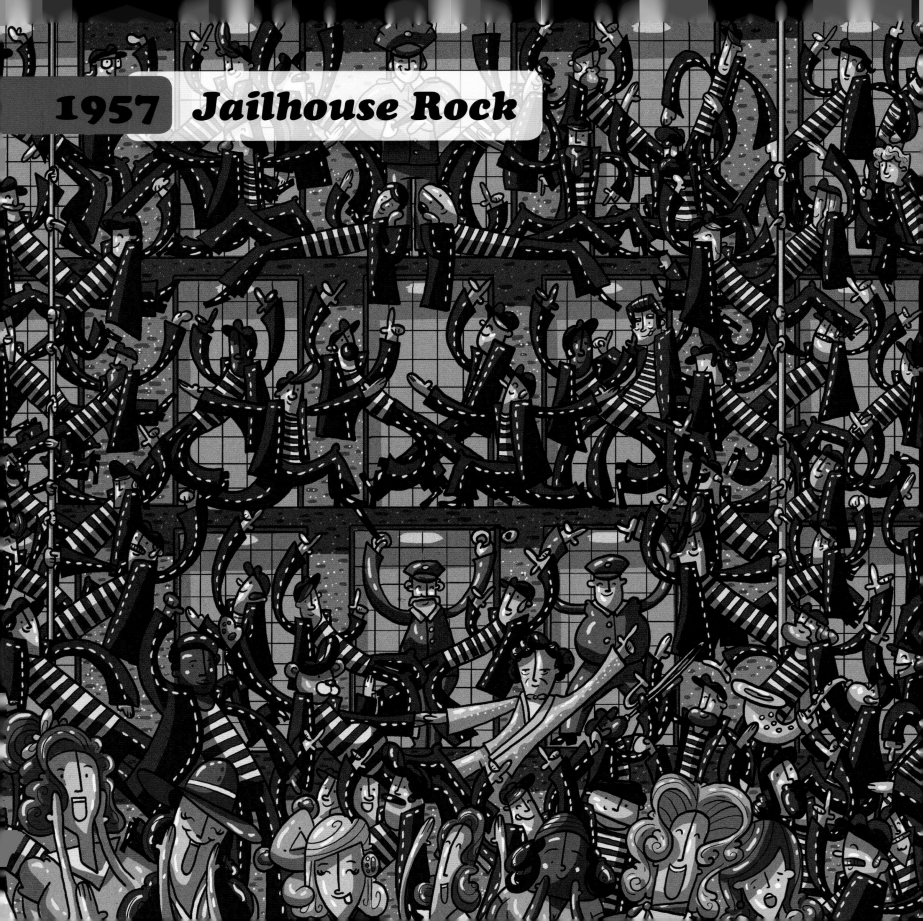

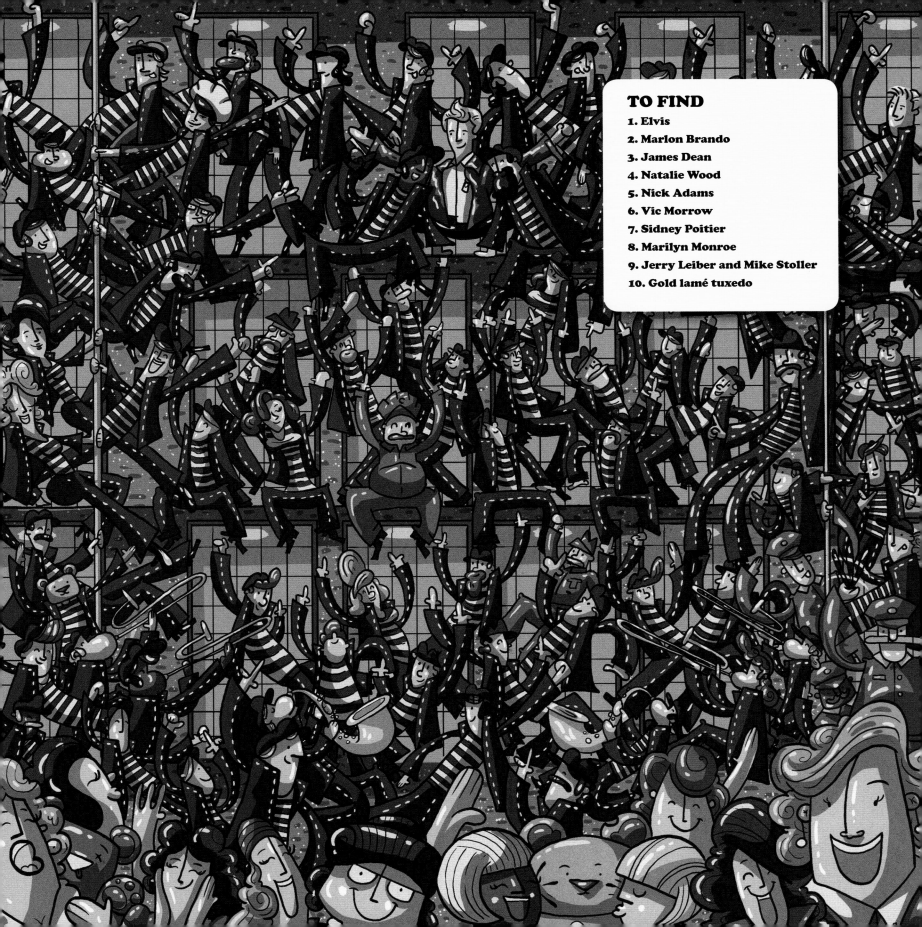

TO FIND

1. Elvis
2. Marlon Brando
3. James Dean
4. Natalie Wood
5. Nick Adams
6. Vic Morrow
7. Sidney Poitier
8. Marilyn Monroe
9. Jerry Leiber and Mike Stoller
10. Gold lamé tuxedo

Jailhouse Rock

Elvis's goal was to follow in the footsteps of his acting idol James Dean, and in *Love Me Tender*, he had some Dean-worthy moments, shaking Debra Paget in a fit of jealousy and howling over the body of his wounded brother. "Elvis can act," the *Los Angeles Times* declared.

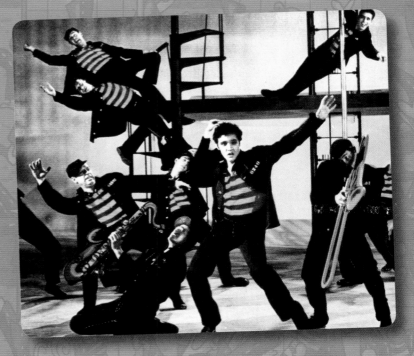

Above: The dance sequence was the precursor to the modern music video.

In *Loving You* (1957) Elvis grapples with the pressures of his meteoric rise. Lustful fans ambush him, jealous boyfriends fight with him, and outraged parents try to cancel his television debut, before his manager (Lizabeth Scott) reminds city hall that America was founded on free speech.

Jailhouse Rock (also 1957) came courtesy of Nedrick Young, a blacklisted writer who won an Oscar the following year for his tale of interracial convicts, *The Defiant Ones*. *Stage Show* producer Jack Philbin had proclaimed "He's a guitar-playing Marlon Brando!" when he first saw Elvis, and in this, his third film, the singer gives his most Brando-esque performance, often with a bitter sneer. In one scene he smashes a guitar perilously close to a heckler's head. He stalks out of a cocktail party when the parents of his love interest (actress Judy Tyler) get pretentious about jazz, then kisses Tyler aggressively—the cinematic equivalent of the anti–high class diatribe in "Hound Dog." With *Jailhouse*, Elvis arrived as a real actor, listening and reacting to his fellow performers, unassailably cool. If he had only made *Jailhouse Rock*, *King Creole*, *Flaming Star*, and *Wild in the Country*, his cinematic reputation would be entirely different.

But the reason the movie was added to the United States National Film Registry in 2004 was the legendary "Jailhouse Rock" dance sequence, in which Elvis performs on a TV set made to resemble a prison. Choreographer Alex Romero originally envisioned a more traditional musical number, but Elvis insisted his moves had to emerge naturally like they did onstage, and enlisted *West Side Story* dancer Russ Tamblyn for some pointers.

Also key to the scene's success was Jerry Leiber and Mike Stoller's risqué composition. They hadn't met Elvis yet when they wrote it. At the time, they didn't take him seriously. They only respected hardcore black artists, though they were Jewish themselves, their anti-establishment bent fueled by a brief run in a Marxist commune. But at the soundtrack recording session, Elvis told them how much he had enjoyed their records, even before he recorded for Sun Records. They were surprised to learn that he knew arcane blues classics they didn't think anybody else had ever heard of. They were further impressed with his inexhaustible determination to record 29 takes. Elvis delivered the lines with a ferocity they hadn't expected, perhaps informed by his own father's experience behind bars.

The sequence codified Elvis's stage moves from 1955 to 1957, along with his smile, humor, and grace—preserving the moment when he was the hippest guy on the planet, inspiring a generation to loosen up. Romero said Elvis told him years later that he felt the scene was "the best number I've ever done in anything." *Time* magazine ranked it among the top ten movie dance scenes. Not long after the shoot, Elvis was driving with friends when his new number-one hit came over the radio. He pulled over on a side street, blasted the speakers, jumped out, and did the "Jailhouse Rock" in the beam of headlights in the rain.

DID YOU FIND?

1. Elvis

2. Marlon Brando
As the biker in *The Wild One* (1953), Brando popularized leather jackets and jeans, and inspired a wave of juvenile delinquency films. His naturalistic style of method acting exposed how mannered and unrealistic most of his contemporaries were, just as Elvis's raw passion made the hit parade seem tepid.

3. James Dean
Of the late actor, killed in a car crash in 1955, Elvis said, "I've made a study of poor Jimmy Dean. I've made a study of myself, and I know why the girls, at least the young 'uns, go for us. We're sullen, we're broodin', we're something of a menace. I don't understand it exactly, but that's what the girls like in men. I don't know anything about Hollywood, but I know you can't be sexy if you smile. You can't be a rebel if you grin."

4. Natalie Wood
The star of *Rebel Without a Cause* and *Splendor in the Grass* visited Elvis in Memphis.

5. Nick Adams
He was another *Rebel* alumnus, and Elvis loved to hear his stories about his friendship with Dean.

6. Vic Morrow
Having excelled as a sinister hoodlum in *The Blackboard Jungle* (1955), Morrow was cast as the thug who leads Elvis astray in *King Creole*.

7. Sidney Poitier
After gaining attention in *Blackboard Jungle*, Poitier became the first African American to be nominated for the Best Actor Oscar in *The Defiant Ones*, written by *Jailhouse Rock* scriptwriter Nedrick Young, and won in 1963 for *Lilies of the Field*.

8. Marilyn Monroe
Like fellow icon Elvis, Monroe inspired a wholesale reevaluation of conventional mores as she flouted the good girl/bad girl paradigm. The two legends met only once, on the Paramount lot while Elvis filmed *G.I. Blues*.

9. Jerry Leiber and Mike Stoller
Elvis considered this songwriting duo his good-luck charm, and recorded 23 of their songs. But they distanced themselves after the Colonel tried to bully them into signing a blank contract, in a strange echo of the *King Creole* plot.

10. Gold lamé tuxedo
Inspired by Liberace's opulent wardrobe, the Colonel commissioned celebrity tailor Nudie Cohn to fashion a $2,500 gold-leaf suit for his client. Elvis wore it onstage for the first time in Chicago on March 28, 1957, and on one of his best album covers for *50,000,000 Elvis Fans Can't Be Wrong*.

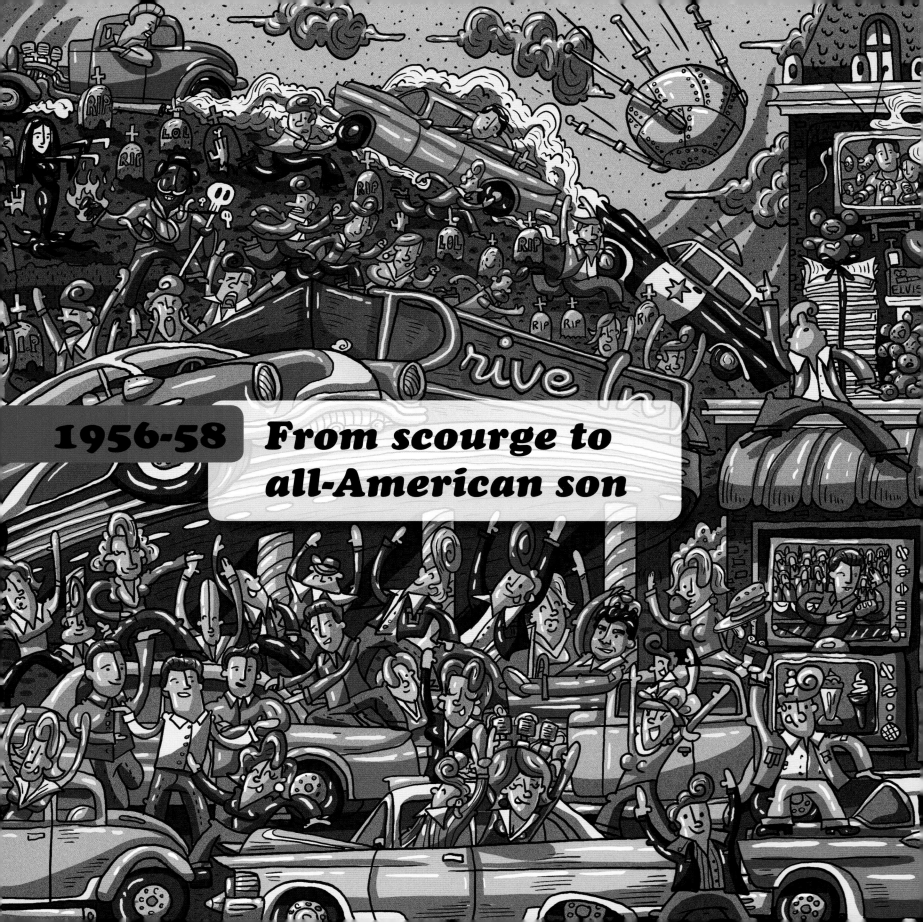

1956-58 From scourge to all-American son

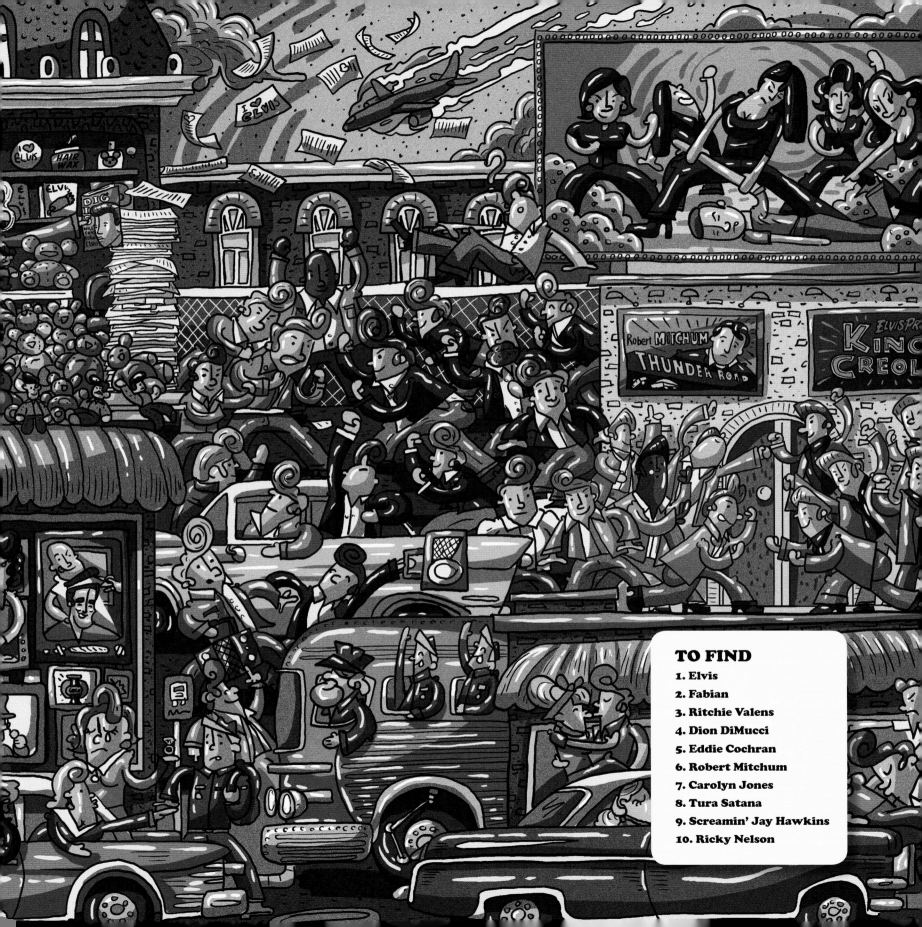

TO FIND
1. Elvis
2. Fabian
3. Ritchie Valens
4. Dion DiMucci
5. Eddie Cochran
6. Robert Mitchum
7. Carolyn Jones
8. Tura Satana
9. Screamin' Jay Hawkins
10. Ricky Nelson

From scourge to all-American son

In Jacksonville, Florida, a judge told Elvis he'd be arrested if he moved in any way that "impaired the morals of minors," so that night he just stood still on stage and wiggled his little finger.

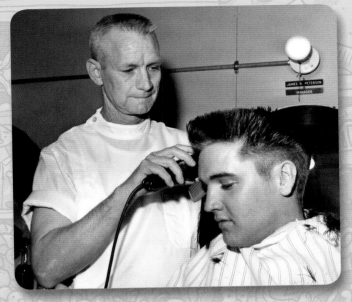

Above: Elvis receives a crew cut on his first full day as a member of the U.S. Army on March 24, 1958.

He was burned in effigy in Nashville, St. Louis, and Houston, and branded "morally insane" by an Iowa preacher. The *Catholic Sun* denounced "his voodoo of frustration and defiance." The Montreal Catholic Church announced that any Catholic who attended his show would be excommunicated, so the city canceled the gig. Schoolgirls were expelled in Ottawa for seeing him in concert, and in Albuquerque for kissing him when he gave them his autograph. In Los Angeles, the vice squad filmed his performance.

To clean up his image, he sang the Christian standard "Peace in the Valley" during his final *Ed Sullivan* appearance on January 6, 1957. Sullivan put his arm around Elvis and shook his hand. "I wanted to say to Elvis Presley and the country that this is a real decent, fine boy." Elvis released a gospel collection and a Christmas album. But four days before Christmas 1957, he received a gift he wasn't hoping for—his draft notice.

The army gave him a 60-day deferment to shoot *King Creole*, a film originally planned for James Dean. With the help of *Casablanca* director Michael Curtiz, Elvis was alternately soulful and smoldering, even making use of his stuttering problem to convey his nervousness with love interest Dolores Hart. The scene where Elvis defiantly sings Leiber and Stoller's

"Trouble" to mob boss Walter Matthau is one of the most compelling in his filmography.

Costar Jan Shepard recalled the time she and Elvis were in a café: "I said to Elvis, 'Marlon Brando is sitting behind you.' Elvis said, 'Oh, my God' and his head sunk into his sandwich. I said, 'Look, he wants to meet you, I saw him looking at you, just say hi to him . . .' He got up and bumped his chair. Marlon stood up and the two of them shook hands. They did a little small talking. Elvis was very cool. Elvis then walked out of the café very cool. But the minute we got outside he leaped up. He couldn't believe he met Marlon Brando. He was so excited, we just danced all the way back to the studio." Referring to the film's New Orleans locale, one reviewer branded Elvis a "Bourbon Street Brando," and now even the *New York Times* decided, "Elvis Presley can act." He later judged it his favorite of his films.

Although Elvis was offered the cushy option of entertaining the troops, he decided to serve with no special treatment. On March 24, he received his military haircut, which the 55 reporters and photographers present duly infused with symbolic significance. But if his fellow draftees hoped to see Elvis crack under the pressure, he ended up impressing them with his

resolve to carry out his duties just like everybody else, whether marching with a pack on his back or cleaning the latrines.

Sadly, the event that made countless more sympathize with him was the death of his mother on August 14, 1958, from heart failure due to acute hepatitis and cirrhosis of the liver, at the age of only 46. Biographer Pat Broeske said that when Elvis attended her funeral, "It was probably one of the most public displays of grief from a person. The man couldn't walk when he got out of the car. They had to help him. And he had tears streaming down his face. If you've ever seen any of the film footage, it's heartbreaking."

DID YOU FIND?

1. Elvis

2. Fabian
When Fabiano Forte was 14 years old, a record producer spotted him on the street and felt his looks would make him popular with Elvis fans. Supplied with songs like the anthemic "Turn Me Loose" by future Elvis writers Doc Pomus and Mort Shuman, Fabian followed Elvis to the big screen with *Hound Dog Man*.

3. Ritchie Valens
Valens was only able to release three singles, including "La Bamba," before the plane carrying him, Buddy Holly, and the Big Bopper crashed on February 3, 1959, the event immortalized in "American Pie" as "the day the music died."

4. Dion DiMucci
Buddy Holly offered the doo-wop singer a chance to fly on the doomed plane, but DiMucci didn't want to spend the $36 and gave up his seat to Valens.

5. Eddie Cochran
Cochran began playing rockabilly after seeing Elvis in Dallas in 1955, and was another rocker killed too young when a taxi carrying him crashed on August 17, 1960. Gene Vincent was in the car, but survived.

6. Robert Mitchum
The iconoclastic actor wrote the part of his younger brother in *Thunder Road* (1958) specifically for Elvis, but the Colonel wanted more than the budget could afford. The film's poster later inspired Bruce Springsteen's song of the same name.

7. Carolyn Jones
She played the tormented gangster's moll in *King Creole* before gaining fame as Morticia on TV's *The Addams Family*.

8. Tura Satana
Part Japanese, Filipina, Cheyenne, and Scots-Irish, Satana's father taught her martial arts and she formed a leather-jacketed girl gang to patrol the neighborhood and protect the females. She met Elvis in 1955 and taught him some of his dance moves as well as some karate. Ten years later she became a cult icon in the film *Faster, Pussycat! Kill! Kill!*

9. Screamin' Jay Hawkins
After the R&B singer released his demented masterpiece "I Put a Spell on You," Alan Freed paid him to rise out of a coffin onstage while holding a smoking skull named Henry. He later acted in Jim Jarmusch's Elvis-inspired feature *Mystery Train* (1989).

10. Ricky Nelson
Elvis told Nelson he watched him on *The Adventures of Ozzie and Harriet* all the time. Elvis's backing vocalists, the Jordanaires, sang on Nelson's songs, too. Nelson's guitarist, James Burton, would join Elvis's band in 1969.

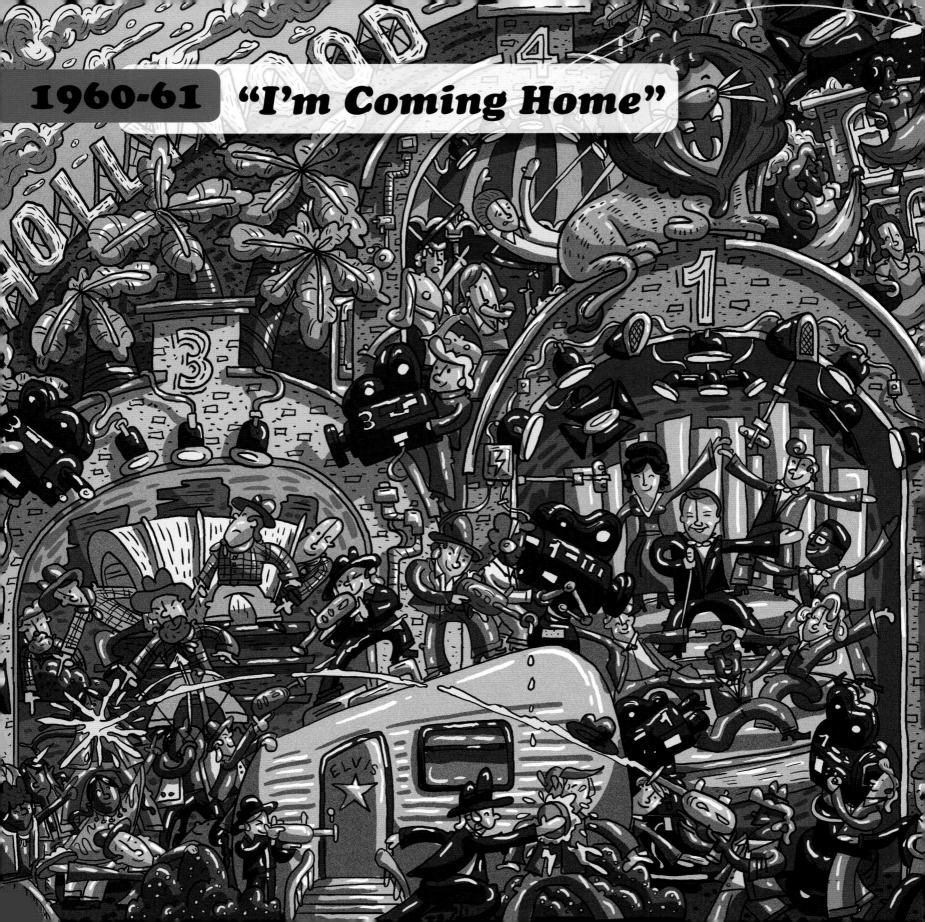

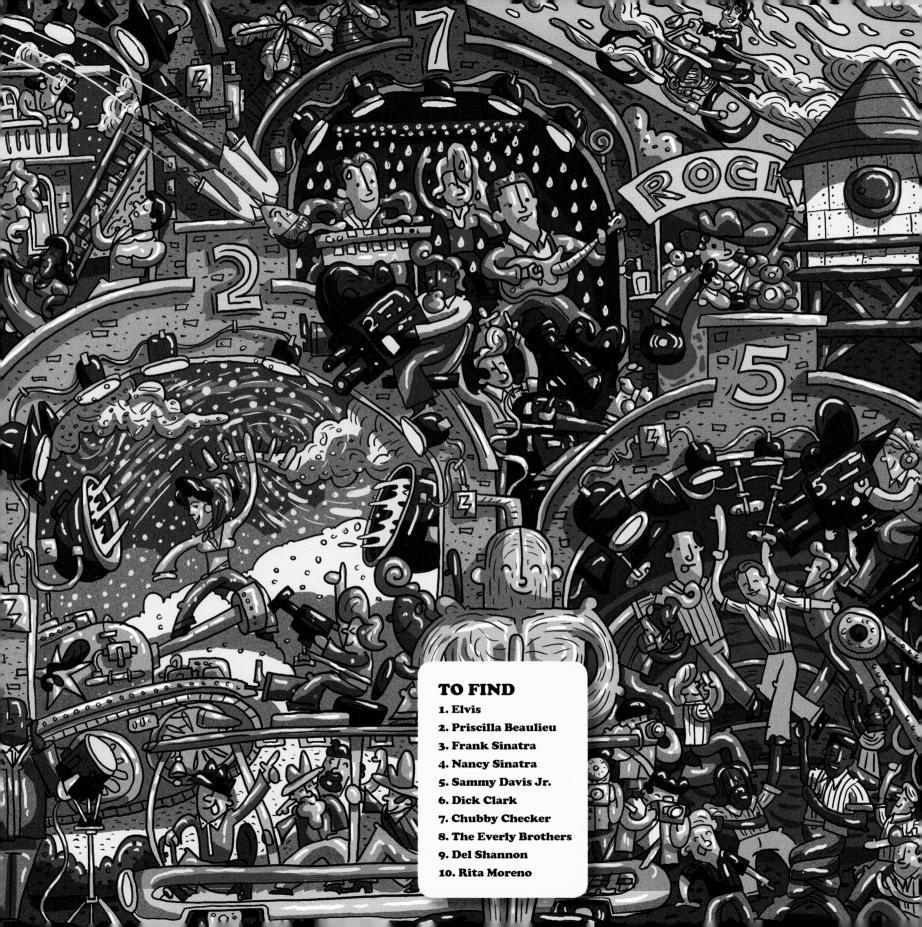

TO FIND

1. Elvis
2. Priscilla Beaulieu
3. Frank Sinatra
4. Nancy Sinatra
5. Sammy Davis Jr.
6. Dick Clark
7. Chubby Checker
8. The Everly Brothers
9. Del Shannon
10. Rita Moreno

"I'm Coming Home"

The song Elvis chose to cut first at recording sessions often packed an extra wallop, and that held doubly true for Otis Blackwell's rousing "Make Me Know It" on March 20, 1960, as it marked Elvis's return to the studio after his 18-month military service in Germany.

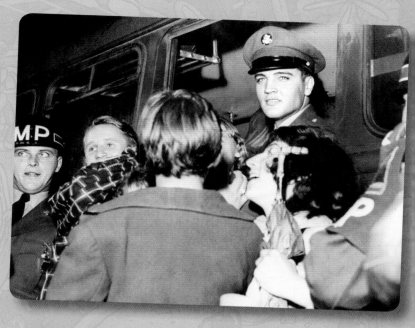

Above: Elvis was promoted to sergeant and learned karate while stationed in Friedberg, Germany, from 1958 to 1960.

Bill had gone solo, but Scotty, D.J., and Floyd were joined by the crème of the Nashville A-Team session musicians, as they would be for much of the decade: Bob Moore on double bass, Buddy Harman on a second set of drums, Hank Garland on guitar, and Boots Randolph on sax. (Randolph's 1963 hit "Yakety Sax" was used as the theme to *The Benny Hill Show*, which is why his sound evokes the feel of crazy chase scenes to many.)

Elvis Is Back! stands as one of his top four albums. Bluesy numbers comprise a third of the LP, and black quartet songs like "Milky White Way" were highlights of his 1960 gospel album *His Hand in Mine*. But thereafter the blues waned as a Latin influence rose in the wake of his biggest hit, "It's Now or Never."

When Elvis met his future wife Priscilla Beaulieu at a party in Germany, they bonded over their appreciation of operatic tenor Mario Lanza. Eager to prove he could do more than rock, Elvis had the 1898 Italian ballad "O Sole Mio" Americanized, and his version sold over 20 million copies, still standing as the eighth best-selling single of all time.

Brill Building writing team Doc Pomus and Mort Shuman turned a 1902 Neapolitan ballad into "Surrender," and there followed a string of tracks adapted from Italian or Spanish songs: "Ask Me," "No More," "You'll Be Gone," "Santa Lucia," "You Don't Have to Say You Love Me." Other Latin-influenced songs included "Kiss Me Quick," "Fountain of Love," "The Walls Have Ears," "Never Ending," "Heart of Rome," the *Fun in Acapulco* soundtrack, "Do the Vega" (rhumba), "I'll Take Love" (mambo), and best of all, Pomus and Shuman's bossa nova "Suspicion."

As Elvis faded from the R&B and country charts, he rose on easy listening (later rebranded adult contemporary). In contrast to his previous studio albums, 1961's *Something for Everybody* opened not with a rocker but with the ballad "There's Always Me" by Don Robertson, Elvis's favorite composer of the early 1960s. He covered 14 of his songs, many featuring Robertson's distinctive "slip-note" piano sound.

Still, on "Little Sister," Elvis told the musicians to "Burn!" and Hank Garland delivered the fiercest guitar on a Presley record to date. On the flip, they steamed through "(Marie's the Name) His Latest Flame" with relentless efficiency, increasing the heartbreak by underplaying it.

He pushed himself onscreen as well. *Burning Star* (1960), helmed

by *Dirty Harry* director Don Siegel, was one of the first Hollywood films to portray Native Americans in a sympathetic light (Elvis's great-grandmother was Cherokee). In *Wild in the Country* (1961), Hope Lange played a psychologist helping Elvis channel his anger issues into becoming a writer. He used method acting techniques by incorporating the true story of how his mother poured buttermilk on her arms to soothe them after a long day picking cotton.

Even playing a cocky but likable charmer in the musical comedy *G.I. Blues* (1960) seemed a commendable change of pace from tortured hoodlums, initially. That film and *Blue Hawaii* (1961) were among the top-grossing U.S. films of their years. The *Blue Hawaii* soundtrack was one of the biggest-selling U.S. pop albums of the entire decade—second only to the *West Side Story* soundtrack—propelled by the lush majesty of "Can't Help Falling in Love," set to the melody of the 1874 French song "The Pleasure of Love."

DID YOU FIND?

1. Elvis

2. Priscilla Beaulieu
The stepdaughter of a U.S. Air Force officer stationed overseas, she reminded Elvis of his *Love Me Tender* costar Debra Paget. *Life* magazine took photos of her waving good-bye to Sgt. Presley when he returned to the States.

3. Frank Sinatra
"The Chairman of the Board" denounced rock and roll in 1957, but when his television ratings faltered in 1960, he sang a duet with the King on *The Frank Sinatra Timex Show: Welcome Home Elvis*.

4. Nancy Sinatra
To promote the show, Frank's daughter was on hand to greet Elvis at the airport when he arrived from Germany. In 1968 they starred together in *Speedway*.

5. Sammy Davis Jr.
The Rat Packer was a good friend of Elvis's who saw him every few years, according to the Memphis Mafia (the nickname for Elvis's entourage).

6. Dick Clark
The clean-cut host of *American Bandstand* brought rock and R&B into America's living rooms from 1957 to 1987.

7. Chubby Checker
Dick Clark's wife renamed Ernest Evans in honor of Fats Domino. After Elvis and the hula-hoop (which debuted in 1957), the gyrations of Chubby's dance "The Twist" were no longer controversial.

8. The Everly Brothers
Nashville's A-Team backed these masters of vocal harmony in the studio.

9. Del Shannon
The Michigan rocker was the first to record "His Latest Flame." Elvis covered "Runaway" in 1970's *On Stage*.

10. Rita Moreno
The *West Side Story* star dated Elvis briefly to make the love of her life, Marlon Brando, jealous. Elvis was offered the lead in the 1961 musical drama, but the Colonel turned it down; it went on to win 10 Oscars, and it could have set Elvis on an entirely different cinematic course.

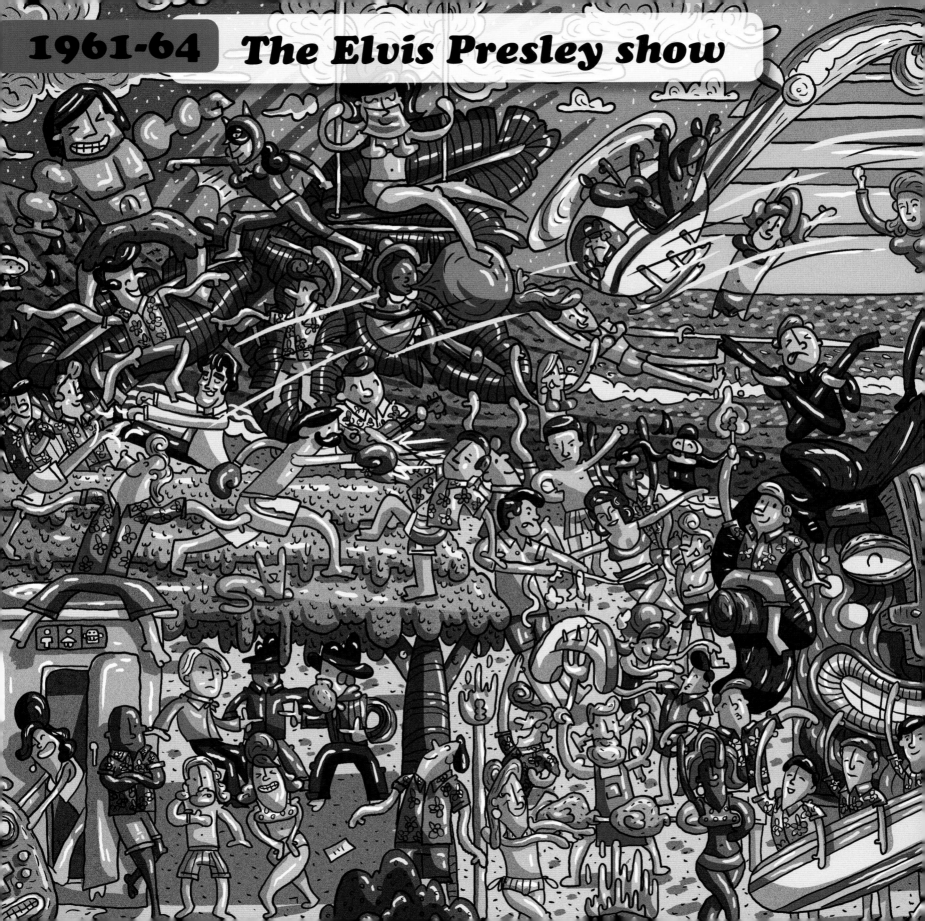

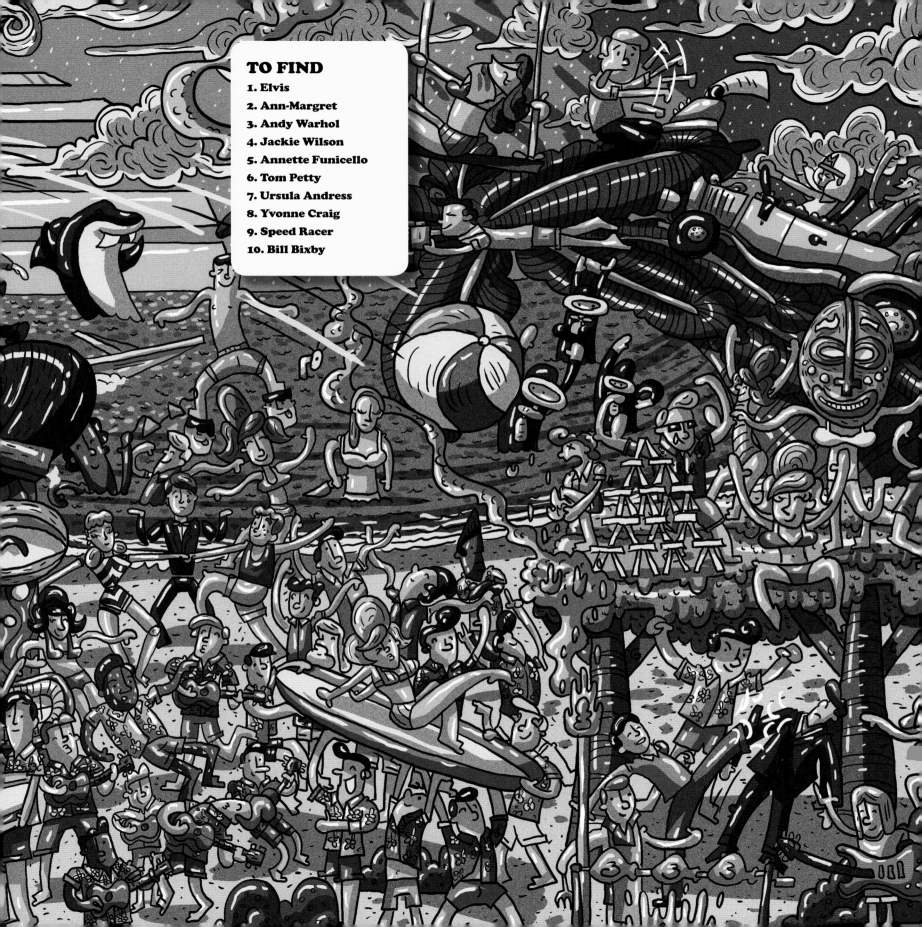

TO FIND

1. Elvis
2. Ann-Margret
3. Andy Warhol
4. Jackie Wilson
5. Annette Funicello
6. Tom Petty
7. Ursula Andress
8. Yvonne Craig
9. Speed Racer
10. Bill Bixby

The Elvis Presley show

Elvis's sixties films are perhaps best appreciated as one long-running program that ran from 1960 to 1969, akin to *The Beverly Hillbillies*, *The Love Boat*, or *Happy Days*, but shot in gorgeous widescreen Technicolor, most containing an enduring song or two.

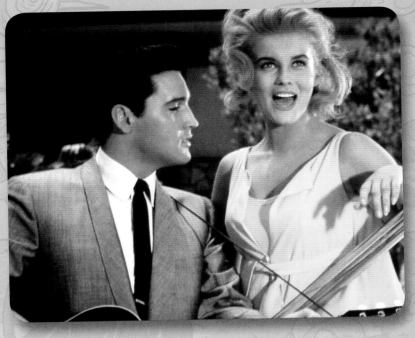

Above: Elvis with Ann-Margret in Viva Las Vegas *(1964).*

He typically played a guy with a macho job like U.S. Navy frogman, bull rider, or boxer; or who worked somewhere unusual like a carnival, dude ranch, or riverboat casino; or who traveled somewhere intriguing, such as Seattle, London, or the Middle East. There he juggled multiple beauties, brawled, won a car or boat race, and occasionally found a treasure.

When he and his friends danced to "Slicin' Sand" in *Blue Hawaii*, it was an integral moment in the birth of the beach movie genre, and thereafter a third of his films took place by an ocean or a hotel pool. (Also, after the *Blue Hawaii* song "Beach Boy Blues" was released on November 22, 1961, a band called the Pendletones was renamed the Beach Boys on December 8.)

A sixth of his movies were westerns, and he often crooned to little kids. Frequently, the films opened with Elvis singing exuberantly while on the move: on the back of a truck, flying in a crop-dusting plane amid the clouds, or rolling down the Florida highway with his family in a jalopy. In optimistic anthems like "Follow That Dream," "Beyond the Bend," "What a Wonderful Life," "King of the Whole Wide World," "Roustabout," and "Once Is Enough," he doesn't have any money or

know where he's going, but he's free and determined to "do some living."

The soundtrack albums were primarily recorded in Los Angeles, with two released each year on average. He also recorded one non-soundtrack album a year in Nashville in the early 1960s. In May 1963, he cut his strongest collection since *Elvis Is Back!* Nine of the 14 tracks were up-tempo, as if to counterbalance 1962's *Pot Luck*, which had been three-quarters ballads. But Elvis's soundtrack albums sold two to four times as much as his nonmovie albums, as they had the films to advertise them, so the decision was made to use the new tracks as bonus cuts on five of the next soundtracks. In 1990 RCA put the songs back together as *The Lost Album*.

In July 1963, Elvis filmed *Viva Las Vegas*, and discovered his costar Ann-Margret shared the same sense of humor and passion for music and motorcycles. In "C'mon Everybody" she challenged him not to be upstaged by her own shaking hips in sexy black leotards, and galvanized him to turn his performance of Pomus and Shuman's title track into a tour de force. With cocked eyebrow and good-natured sneer, he snapped his fingers, ran in place, and glided in sync with showgirls, all in one take. The couple

also turned Leiber and Stoller's "You're the Boss" into one of the King's sexiest numbers, though it was cut because the Colonel thought Ann-Margret was stealing the picture.

Their incandescent chemistry made *Viva Las Vegas* the 14th highest-grossing film of 1964, and his biggest box-office hit. Ann-Margret called Elvis her soul mate in her autobiography. He was torn between her and Priscilla, but she was driven in her career and he wanted a stay-at-home wife. He married Priscilla on May 1, 1967, and one week later she married Roger Smith, star of television's *77 Sunset Strip*.

They remained friends. Whenever she appeared on stage, he sent roses in the shape of a guitar on opening night.

DID YOU FIND?

1. Elvis
As a sleepwalker in his youth, he once wandered outside in his underwear and was spotted by a girl he had a crush on. Gladys took the knobs off doors so he wouldn't roam.

2. Ann-Margret
In *Bye Bye Birdie* (1963) she played the fan of an Elvis-like rock star who is drafted. The King was approached to play the rocker (who sings the Elvis pastiche "A Lot of Livin' to Do"), but the Colonel turned it down.

3. Andy Warhol
The pop artist did over 22 paintings and silkscreens of Elvis, most based on *Flaming Star*. In 1965 Warhol gifted one to Bob Dylan, who gave it away. In the 21st century, *Double Elvis* sold for $37 million, *Triple Elvis* for $82 million, and *Eight Elvises* for $100 million.

4. Jackie Wilson
Elvis thought Wilson's version of "Don't Be Cruel" was better than his own. He emulated him in "Return to Sender," and in some musical sequences in *Double Trouble* (1967) when Wilson visited him on the set.

5. Annette Funicello
The former *Mickey Mouse Club* star found her second act in a string of beach movies with singer Frankie Avalon, starting with 1963's *Beach Party*.

6. Tom Petty
As an 11-year-old, Petty watched the fans going crazy as Elvis shot *Follow That Dream* (1962) in Florida and decided rock was the gig for him.

7. Ursula Andress
After she emerged from the water in a white bikini in the James Bond film *Dr. No* (1962), the studio paired her with Elvis for *Fun in Acapulco* (1963).

8. Yvonne Craig
She worked with Elvis in *It Happened at the World's Fair* (1963) and *Kissin' Cousins* (1964) before donning a cape as Batgirl on *Batman* in 1967.

9. Speed Racer
Japanese illustrator Tatsuo Yoshida said he was inspired to create his cartoon hero after seeing Elvis race in *Viva Las Vegas* (1964), and gave him Elvis's hairstyle.

10. Bill Bixby
Elvis's buddy in *Clambake* (1967) and *Speedway* (1968) later found TV stardom in *The Courtship of Eddie's Father* and *The Incredible Hulk*.

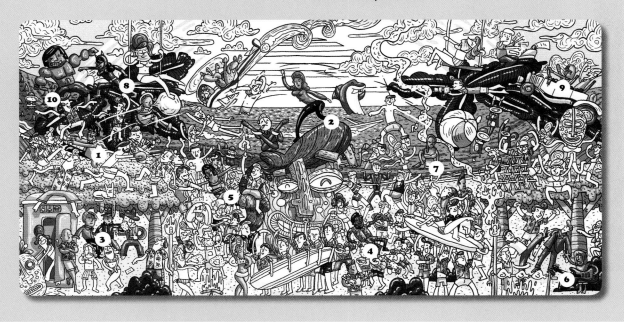

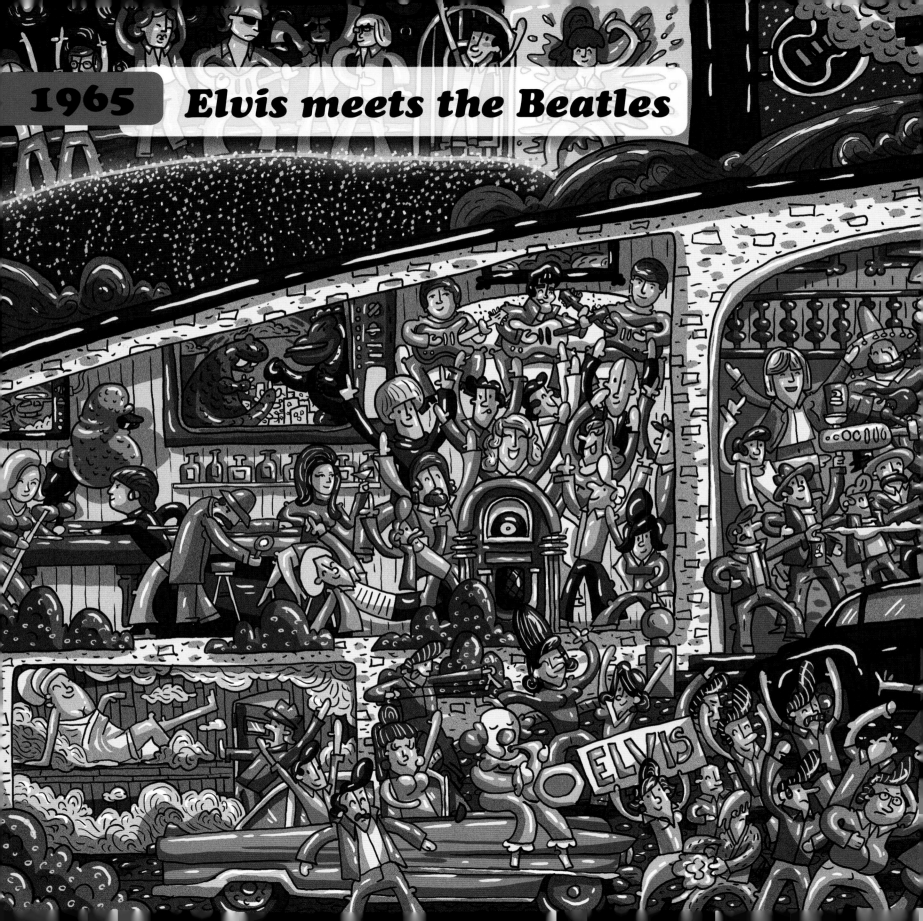

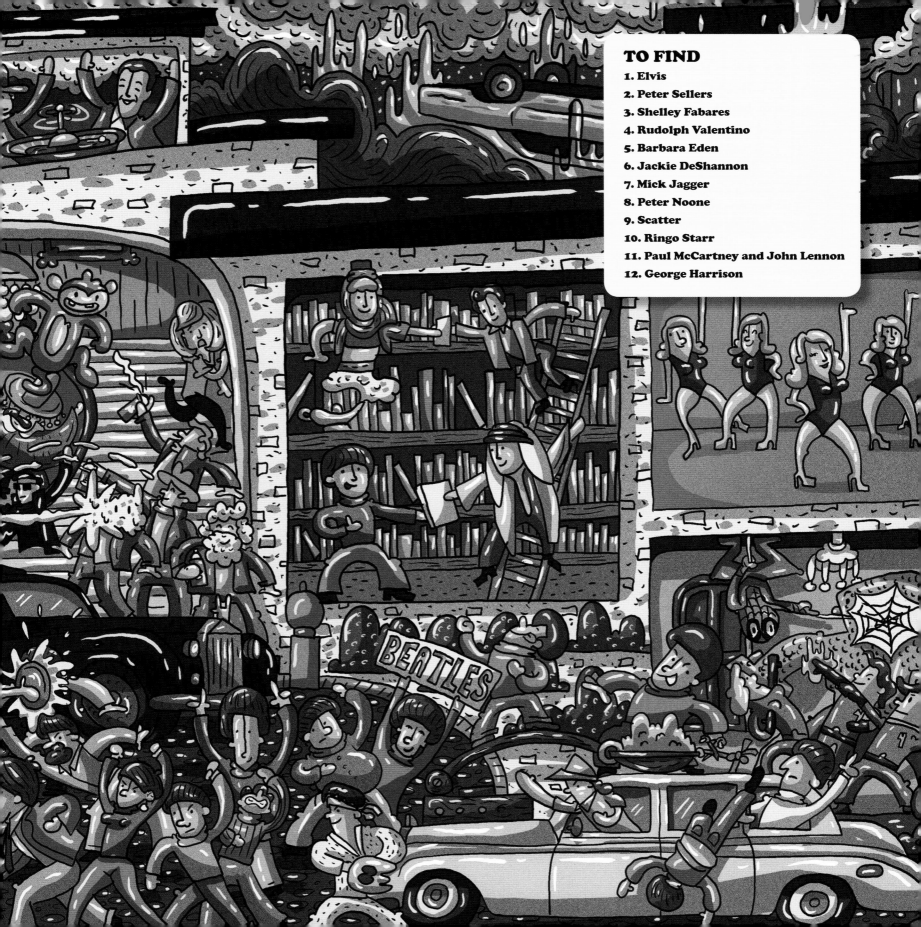

Elvis meets the Beatles

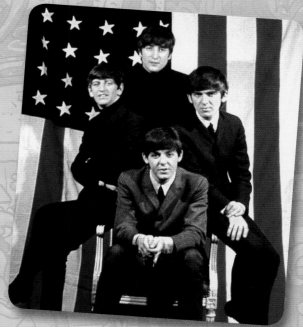

"We'd never heard American voices singing like that," said John Lennon. "They'd always sung like Sinatra or enunciated very well, and suddenly there was this hillbilly, hiccupping on tape echo, and the bluesy background going on, and we didn't know what the hell Elvis was singing about. To us, it just sounded like a noise that was great."

Above: The Beatles in 1964. John Lennon said that without Elvis he "would've been nothing."

Paul McCartney recalled, "If we were feeling lousy, we'd go back and play an Elvis 78—'Don't Be Cruel'—and we'd be right up there again. It could cure any blues." And they each had their share: Paul's mother passed away on October 31, 1956; John's on July 15, 1958; and Elvis's less than a month later on August 14.

In a way, the Beatles' leaders were Elvis split into two: Paul the cute one, Lennon the rebel. A troubled childhood spurred John to adopt Elvis's surly bad-boy persona from *Jailhouse Rock*, and he was almost kicked out of school for growing Elvis sideburns. The Beatles came of age in a real-life version of *King Creole*, playing the red-light district of Hamburg, Germany.

Both the King and the Fab Four were from port cities, and spoke in regional accents that were scoffed at by the recording establishment, but became badges of authenticity. Both built up a backlog of records before breaking into the U.S. hit parade, so that when they did arrive, their songs flooded the charts. Elvis and the Colonel sent a congratulatory telegram when the British group played on *The Ed Sullivan Show* in February 1964.

Four months later, Elvis and the Jordanaires recorded their version of the Beatles' jubilant wailing in "Girl Happy," by Doc Pomus with Jerry Ragovoy, who wrote the Stones' "Time Is on My Side" and numerous Janis Joplin songs. Finally, Elvis invited the band to his mansion in Los Angeles on August 27, 1965.

At first, the foursome stared silently at Elvis (just as they did with their other idol, Bob Dylan), until Elvis cracked, "If you damn guys are gonna sit here and stare at me all night, I'm gonna go to bed." Everyone laughed, then John asked how he dealt with fans who wanted to tear him to pieces. "Son, if you're really scared, you're in the wrong business," Elvis quipped.

Sadly, they never hung out again after that night, perhaps because the Liverpudlians were too blunt. When Elvis boasted of a million-dollar payday for a film that took only 15 days to shoot, John joked, "Well, we've got an hour to spare now. Let's make an epic together, shall we?" (If only they had known they were both fascinated with Eastern mysticism, perhaps they could have bonded over that.)

The next day Paul told an interviewer, "We were trying to persuade

him to . . . do a new session and try and get some of the old kind of songs he used to sing. You know, all the old country songs, or some of the old . . . real rock and roll stuff . . . I don't like the new stuff half as much. And we told him last night, you know, and I think he fancies doing it . . . I'll buy it if he does." When the band returned to England, the first thing they recorded was "Run for Your Life," with lyrics from Elvis's Sun Records single "Baby Let's Play House."

Elvis ultimately racked up 30 number-one singles in both the U.S. and the UK; the Beatles' total was 27. Elvis sold over 50 million singles in the U.S., while the Beatles sold 25 million—though the Fab Four sold 178 million albums in the U.S. compared to the King's 135 million. The worldwide sales of both are more than 600 million units each.

DID YOU FIND?

1. Elvis

2. Peter Sellers
Both Elvis and John were fans, so John talked like Dr. Strangelove during the visit. "Long live ze King!"

3. Shelley Fabares
One of Elvis's favorite costars, she appeared with him in *Girl Happy* (1965), *Spinout* (1966), and *Clambake* (1967).

4. Rudolph Valentino
Elvis paid homage to cinema's "Latin Lover" in *Harum Scarum* (1965).

5. Barbara Eden
After *Flaming Star* (1960) she found fame in *I Dream of Jeannie*, NBC's answer to *Bewitched*.

6. Jackie DeShannon
Eddie Cochran discovered the rockabilly singer-songwriter when she was 16. She briefly dated Elvis and toured with the Beatles.

7. Mick Jagger
Elvis said of Jagger, his successor as rock's most electrifying front man, "That guy looks like a crazed chicken on LSD!"

8. Peter Noone
The lead singer of Herman's Hermits visited Elvis on the set of *Paradise, Hawaiian Style* (1966).

9. Scatter
Elvis's pet chimpanzee terrorized the L.A. neighbors, so the King had to send him back to Graceland.

10. Ringo Starr
In *Loving You* (1957), Elvis goes AWOL before the big show, and in *A Hard Day's Night* (1964), Ringo does the same thing.

11. Paul McCartney and John Lennon
All the Lennon-McCartney songs Elvis covered were written primarily by Paul: "Yesterday," "Hey Jude," "Lady Madonna," and "Get Back." He also covered George's "Something."

12. George Harrison
George had a "rock and roll epiphany" when, aged 13 and on his bike, he heard "Heartbreak Hotel" coming out a window.

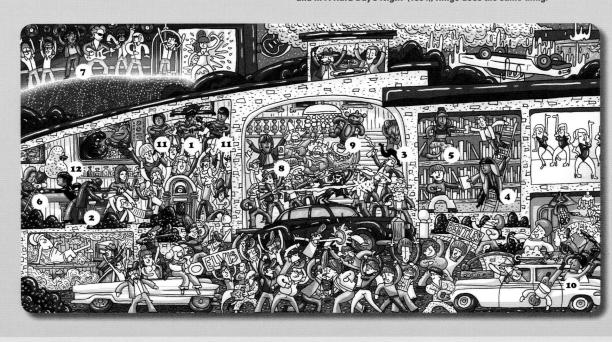

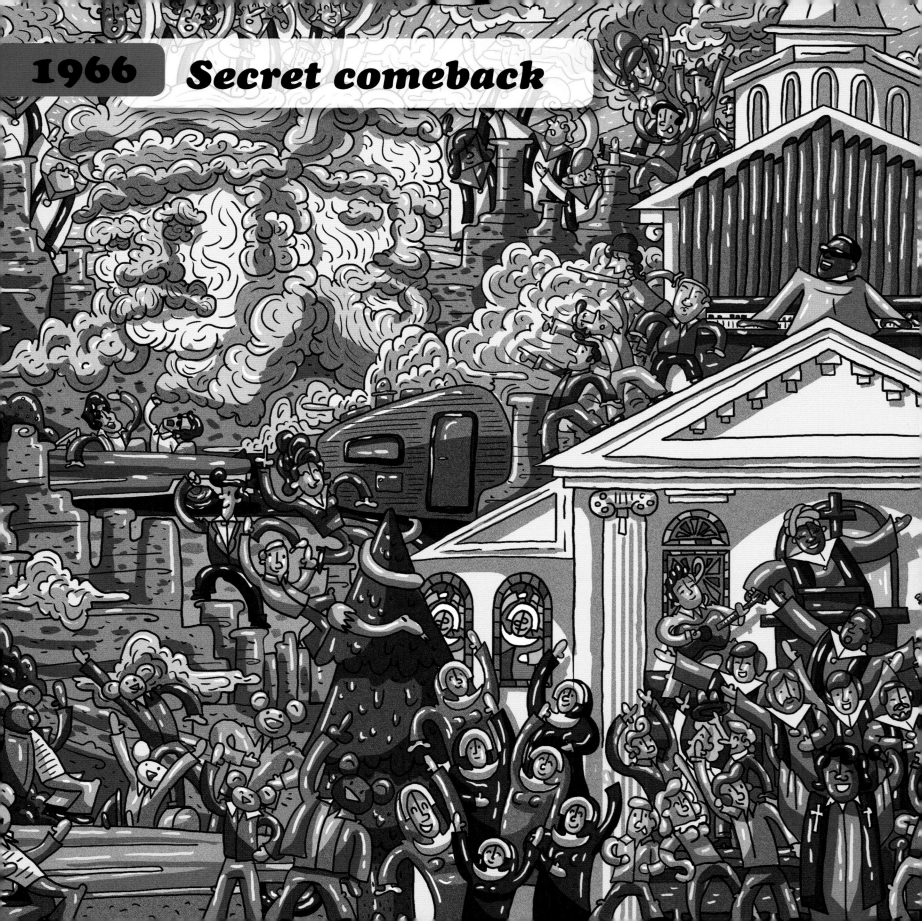

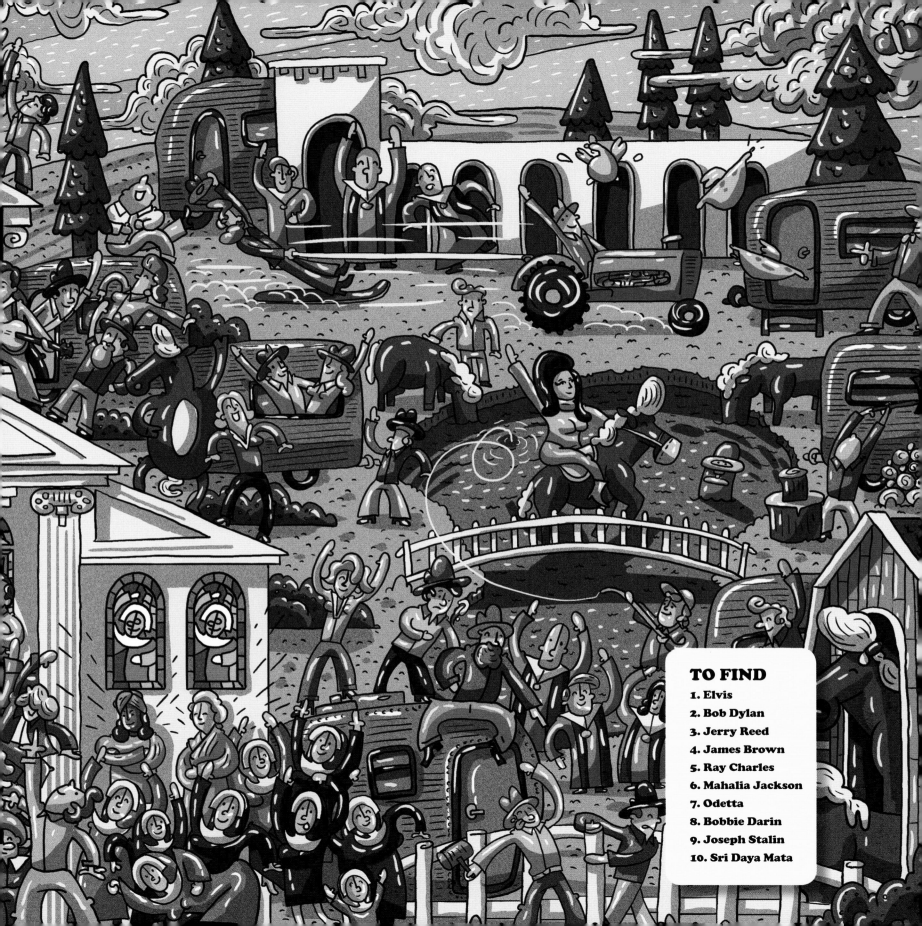

TO FIND
1. Elvis
2. Bob Dylan
3. Jerry Reed
4. James Brown
5. Ray Charles
6. Mahalia Jackson
7. Odetta
8. Bobbie Darin
9. Joseph Stalin
10. Sri Daya Mata

Secret comeback

When Elvis recorded "It Hurts Me" on January 12, 1964, it was a breakthrough toward a heavier, more adult style, with a bitter passion his movies did not give him the opportunity to display. But then the Beatles arrived in February, and he seemed to lose interest in music.

Above: As Elvis prioritized his film career, he scored only one Top 5 hit single, "Crying in the Chapel," from late 1963 to early 1969.

First, they beat him in *The Ed Sullivan Show* ratings (73 million viewers to his 60), then they tied his record for most consecutive number ones, then beat his record for most concurrent singles in the Top 100.

On April 30, 1964, Elvis met his new hairstylist, Larry Geller, who talked about his fascination with metaphysics. Elvis confessed he was searching for his purpose in life. "Why was I picked out to be Elvis?" He became more interested in studying different religions and philosophies with Larry than in finding good songs for his soundtracks, at the very moment the Beatles, Bob Dylan, and the Beach Boys were turning the LP into a cohesive art form.

In 1965 he recorded 32 songs for three films, but the only indisputably great track was the haunting folk song "Sand Castles"— and it wasn't used. Not only were Elvis's songwriters behind the times, the 57-year-old Colonel instructed the engineer to turn Elvis's voice up in the mix to a jarring degree, so that the Colonel's wife could hear him better amid the instruments.

Gradually, Elvis started to care again. "They're screwing with my music!" he told his cousin Billy Smith. Billy said, "He thought the early Beatles were real similar to his early music. He loved the loud, hard-driving sound that they had . . . Occasionally, he wanted his

records to sound raw. For example, he'd ask for the bass to be brought forward a little more in places. And he wanted his voice mixed down, and the music brought up louder, even if it overrode his voice sometimes . . . He'd play a Beatles record, and he'd say, 'This is what I'm looking for right here. I want that drive back.'" (Maybe Elvis Presley Enterprises can correct the Colonel's mixes someday.)

Finally, Elvis returned to Nashville in May 1966. He kept the team waiting while he and Larry meditated, then at 10 p.m. commandeered the traditional folk song "Run On" (a.k.a. "God's Gonna Cut You Down") with the exhilaration of a titan waking up. Next he poured everything he had into the hymn "How Great Thou Art," emerging "white as a ghost, thoroughly exhausted, and in a kind of trance," according to entourage member Jerry Schilling. At 4 a.m. he came back to heavy blues for the first time in six years with the Clovers' "Down in the Alley." He wrapped that night with Dylan's "Tomorrow Is a Long Time." The weariness from a long, productive session perfectly complemented its lyrics about an endless journey.

He started the next evening with the torch song "Love Letters," in the mode of Ketty Lester's moody 1962 version. Its piano intro was an obvious inspiration for John Lennon's 1970 song "God," which

mentioned Elvis in its lyrics. "My soul got happy in the valley," Elvis sang as he laid down some of his most transcendent gospel cuts: "By and By," "If the Lord Wasn't Walking by My Side," "Where Would I Go But to the Lord." He captured the dreamlike ambience of "Beyond the Reef" around dawn, with the otherworldly harmonies by Memphis Mafia members Red West and Charlie Hodge. Later Elvis revisited the Drifters and Clyde McPhatter, then closed with the evocative Hawaiian standard "I'll Remember You," written by Kui Lee.

Had the best of the tracks been released as one album, it would stand among 1966's masterpieces *Revolver*, *Pet Sounds*, and *Blonde on Blonde*. Alas, the secular songs were dispersed, though the gospel songs formed the Grammy-winning *How Great Thou Art*.

DID YOU FIND?

1. Elvis

2. Bob Dylan
"That's the one recording I treasure the most," Dylan said of Elvis's "Tomorrow Is a Long Time" cover.

3. Jerry Reed
Elvis tracked the singer-songwriter down on a fishing trip so he could add his distinctive finger picking to "Guitar Man," and also recorded his songs "U.S. Male," "A Thing Called Love," and "Talk About the Good Times."

4. James Brown
The Godfather of Soul said of Elvis, "I wasn't just a fan, I was his brother." Elvis called James "state of the art . . . No one moves like that man."

5. Ray Charles
Elvis sang "I Got a Woman" onstage from 1955 to 1977, and chose it to open his first RCA recording session. "What'd I Say" was also a mainstay of his act, captured in *Viva Las Vegas*.

6. Mahalia Jackson
She sang "Move on up a Little Higher" by Reverend Brewster of Elvis's beloved East Trigg Avenue Baptist Church, and "Peace in the Valley" was originally written for her. She visited Elvis on the set of *Change of Habit*.

7. Odetta
Elvis first heard "Tomorrow Is a Long Time" on *Odetta Sings Dylan*. She appeared at 1963's March on Washington along with Martin Luther King Jr., Mahalia, and Dylan.

8. Bobbie Darin
He had his own comeback in 1966 with the folk rock "If I Were a Carpenter." Elvis covered his B-side "I'll Be There."

9. Joseph Stalin
After a year of spiritual study, Elvis yearned for a sign from God. A week after recording "Wisdom of the Ages," on March 5, 1965, he was driving Route 66 outside of Flagstaff, Arizona, when he had his vision. An immense cloud formation assumed the face of Joseph Stalin, then dissolved into the smiling visage of Jesus, perhaps a symbol of the dictatorial and benevolent sides that sometimes battled inside him.

10. Sri Daya Mata
Twelve days after his vision, Elvis visited the L.A. Self-Realization Fellowship ashram in Pacific Palisades, founded by Indian mystic Paramahansa Yogananda. Elvis was moved by his book *Autobiography of a Yogi*, and grew close with the spiritual head of the organization, Sri Daya Mata (Faye Wright), whom he called "Ma."

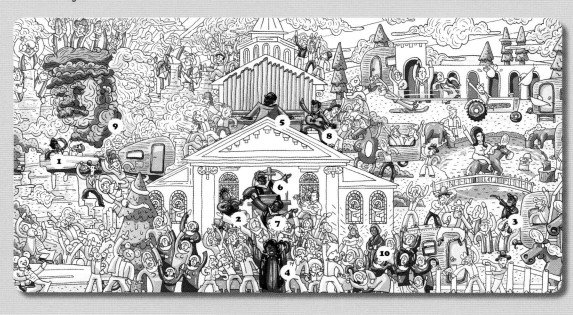

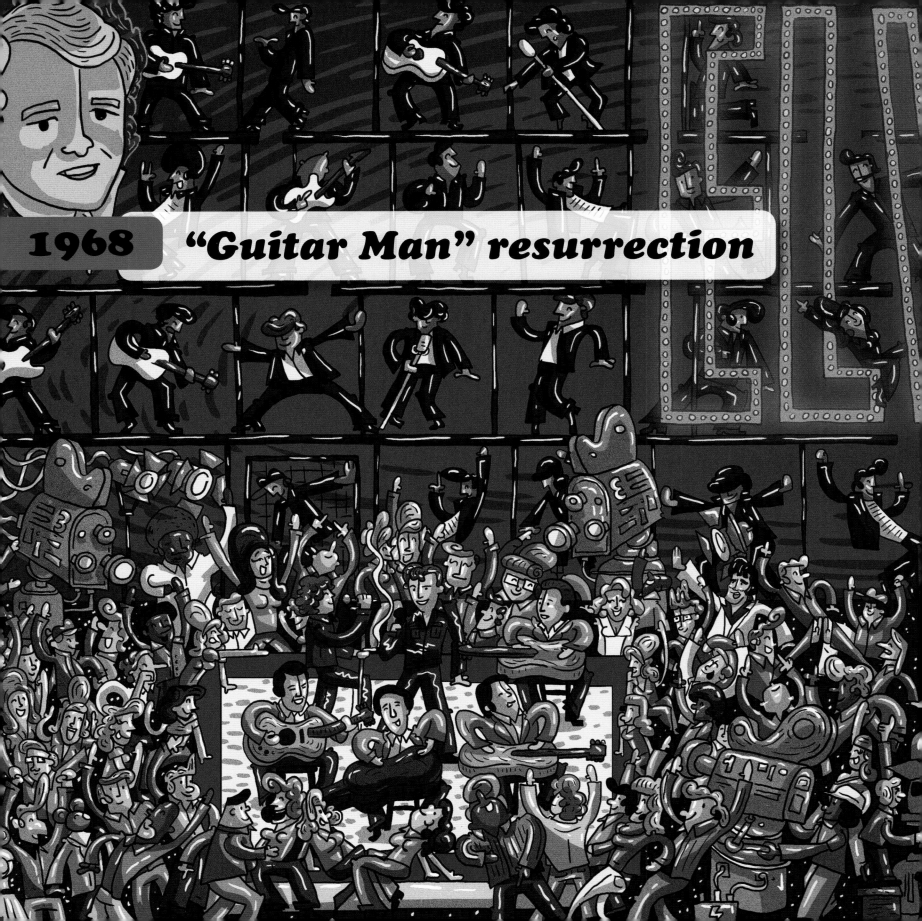

1968 "Guitar Man" resurrection

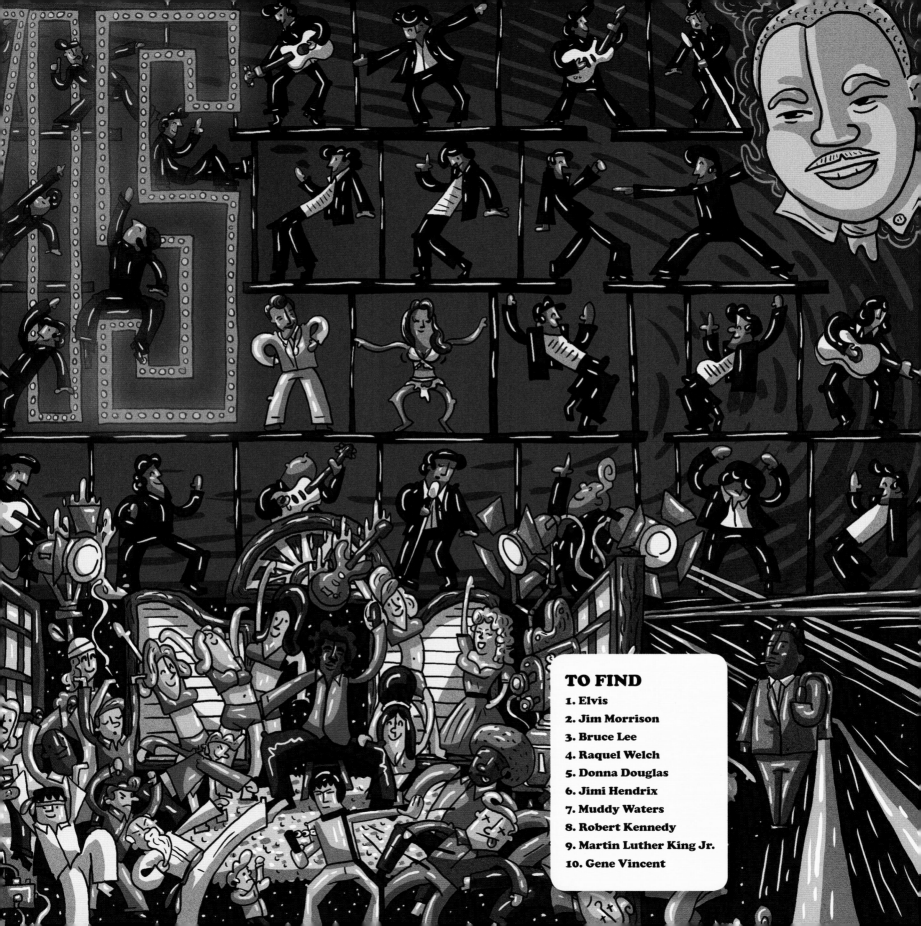

TO FIND

1. Elvis
2. Jim Morrison
3. Bruce Lee
4. Raquel Welch
5. Donna Douglas
6. Jimi Hendrix
7. Muddy Waters
8. Robert Kennedy
9. Martin Luther King Jr.
10. Gene Vincent

"Guitar Man" resurrection

In 1967 the Beatles led the psychedelic movement, and the counterculture looked to rock stars to take a stand on civil rights and the Vietnam War. But Elvis sang "who needs the worry and the strife—gonna have a clambake!" He rode horses on his cattle ranch and married Priscilla. She became pregnant with Lisa Marie during their honeymoon.

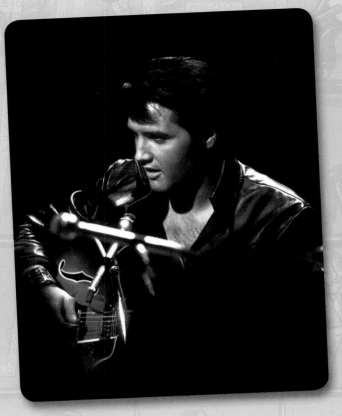

Above: Elvis *was NBC's best-rated show of the year.*

But then financial calamity threatened. His movies once consistently generated around $7 million in total box office receipts, but *Easy Come, Easy Go* plunged to $4 million, *Double Trouble* to $3 million, and *Clambake* to $2 million. His soundtrack albums had once been guaranteed Top 5 hits, but *Double Trouble* crashed to 47.

He rebooted with what many consider the greatest moment of his career, NBC television network's *Elvis*, or *'68 Comeback Special* as it came to be known. Staring into the camera, he intoned *King Creole*'s "Trouble" with the sexy menace of a bad boy grown up, as if the last 10 years hadn't happened, before launching into "Guitar Man" in front of a *Jailhouse Rock* grid overflowing with silhouettes brandishing guitars.

Next, director Steve Binder cut to the singer sheathed in black leather belting out a great lost B-side from 1956, "Lawdy Miss Clawdy." Binder had been charmed by the way Elvis and his friends would sing, joke, and reminisce in his dressing room, and sought to re-create the ambience for the show. In a forerunner to *MTV Unplugged*, Elvis sat on a small stage in the shape of a boxing ring, strumming guitars with Scotty and some members of the Memphis Mafia, while D.J. beat on a guitar case. (Sadly, Bill Black had passed away from a brain tumor in 1965.)

The Beatles had exhorted Elvis to return to his roots, and he did so with a vengeance. "Tiger Man" was an old Sun record by Rufus Thomas, a sequel to "Bear Cat," which had been an answer song to "Hound Dog." Bellowing he was the king of the jungle, Elvis let the rest of rock know he was back for his crown.

The climax lifted the special to an entirely new level. The year was haunted by the April murder of Martin Luther King Jr. Elvis had "sobbed in my arms like a baby" when he heard, recalled Celeste Yarnall, his costar in *Live a Little, Love a Little*. Then, three days after Elvis began working on the TV special in June, Robert Kennedy was gunned down.

After talking about the tragedies with Elvis, Binder had the song "If I Can Dream" written by Walter Earle Brown. It echoed both "Blowin' in the Wind" and King's own "I Have a Dream" speech, which Elvis sometimes recited from memory. Elvis overrode the Colonel's objections and recorded his vocals in the dark, curling into a fetal position on the floor to roar the lyrics about finding the strength to redeem one's soul.

He was back in sync with artists like Dylan, the Stones, and Creedence Clearwater Revival, who were stripping down their sound toward an earlier purity. A month later the Beatles filmed their own *Get Back* project. When the Fab Four sang they were "on our way home," it echoed a review of the special by Jon Landau (later Bruce Springsteen's manager): "There is something magical about watching a man who has lost himself find his way back home."

DID YOU FIND?

1. Elvis

2. Jim Morrison
Briefly, the Doors' front man seemed like a possible contender to Elvis's throne when he appeared on *The Ed Sullivan Show* in September 1967 wearing a black leather suit.

3. Bruce Lee
After starring in the *Batman* spinoff *The Green Hornet*, Lee popularized martial arts in films like *Enter the Dragon*. Elvis began his lifelong study of karate in the army.

4. Raquel Welch
She had an uncredited role in *Roustabout* (1964) before becoming a pinup goddess in *One Million Years B.C.* (1965).

5. Donna Douglas
She starred with Elvis in *Frankie and Johnny* (1966) during the hiatus of *The Beverly Hillbillies*.

6. Jimi Hendrix
When he was 14, Hendrix watched Elvis in concert from a hilltop in Seattle on September 1, 1957, later sketching the singer and writing down his set list.

7. Muddy Waters
King Creole's "Trouble" bore striking resemblance to the blues master's "Hoochie Coochie Man." According to NPR, when Waters heard Elvis's song, he said, "I better watch out. I believe whitey's picking up on the things that I'm doing."

8. Robert Kennedy
After serving as his brother John's attorney general, he ran for president on an antiwar, antipoverty platform.

9. Martin Luther King Jr.
MLK planned to begin the "Poor People's Campaign" in Washington, D.C., to demand full employment and a guaranteed wage for all citizens on April 22, 1968, but he was killed on April 4, 1968.

10. Gene Vincent
When they first heard Vincent's "Be Bop a Lula" in 1956, Scotty and Bill thought Elvis had recorded it behind their back. Vincent wore rock's first black leather suit, and the early Beatles made it their uniform in his honor.

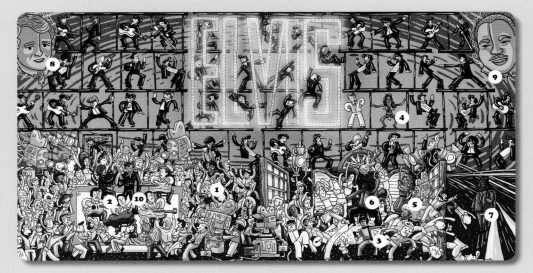

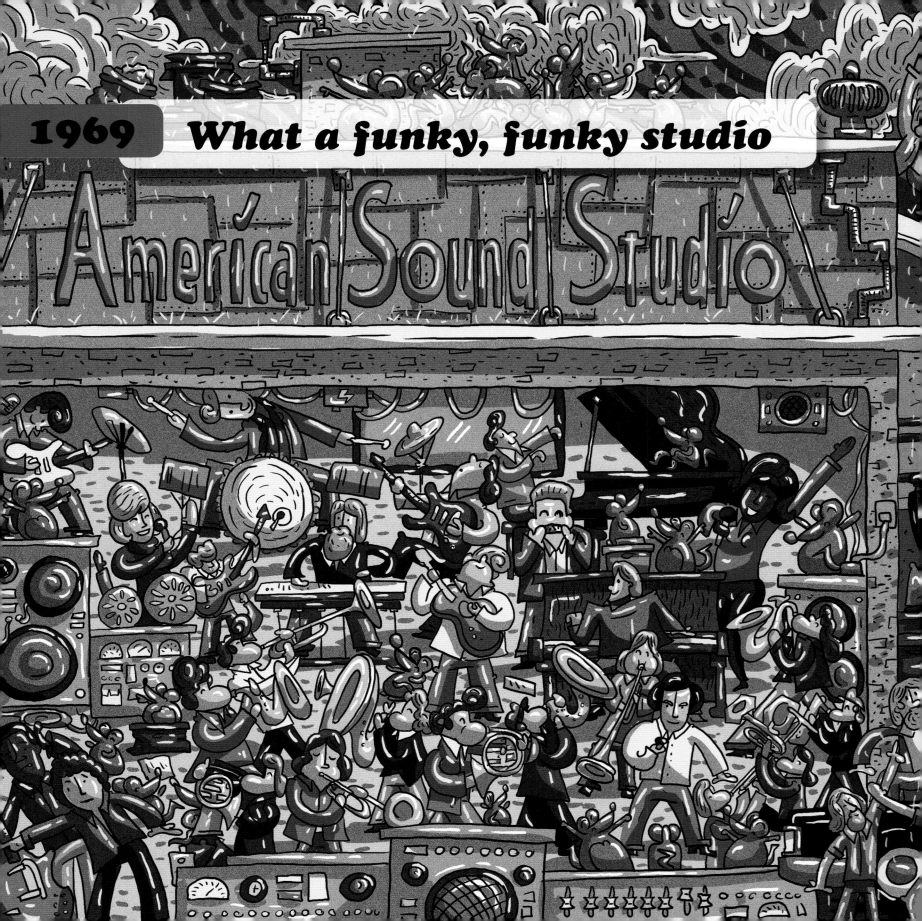

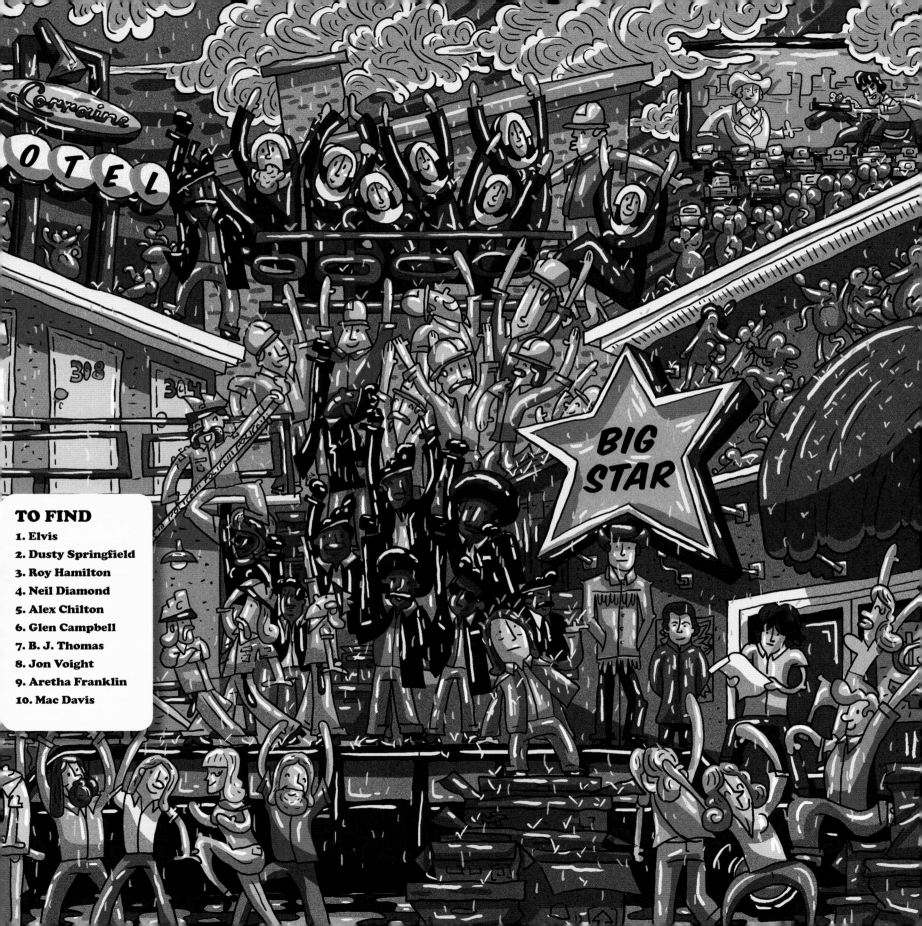

TO FIND

1. Elvis
2. Dusty Springfield
3. Roy Hamilton
4. Neil Diamond
5. Alex Chilton
6. Glen Campbell
7. B. J. Thomas
8. Jon Voight
9. Aretha Franklin
10. Mac Davis

What a funky, funky studio

The Memphis Mafia has sometimes been portrayed as a clique of hangers-on, but entourage members Marty Lacker and George Klein were partly responsible for one of Elvis's greatest albums, *From Elvis in Memphis* (1969), when they pushed their friend to work with Chips Moman, the owner of the Memphis-based American Sound Studio.

Above: A still from the '68 Comeback Special was used for the album From Elvis in Memphis.

Moman had started out at Stax Records, the gritty alternative to Motown. His house band, the Memphis Boys, was all white, but soulful enough that Aretha Franklin used them, along with Bobby Womack, Joe Tex, and Dusty Springfield. The sound they created with Neil Diamond and B. J. Thomas was fast becoming one of the most distinctive in adult contemporary, country-tinged pop.

From the outside the building looked run-down, and indeed there were rats in the walls. When Elvis walked in on January 13, 1969, he proclaimed, "What a funky, funky studio." Horn player Wayne Jackson remembered, "The studio was guarded by dogs, and there was a man on the roof with a gun minding the parking lot."

When Moman pushed Elvis to redo a take, saying he could do better, it was the first time the Mafia had ever heard someone do that, and they worried about how Elvis would react. But Elvis was hungry again, and later said he worked harder at American Sound than at any other time in his life.

From Elvis in Memphis is ostensibly comprised of three originals, three R&B covers, and six country covers, but its greatness lies in the country-soul fusion, like when the band cooks on Hank Snow's "I'm Movin' On" the same way they did for King Curtis when he cut "Memphis Soul Stew." The LP features the most distinctive bass on any Elvis record, by Tommy Cogbill, cranked as high in the mix as in a James Brown record. On many tracks, Moman created an epic soundscape with violas, cellos, French horns, trumpets, and trombones.

The song Elvis started the session with was "Long Black Limousine," a country tune recently covered by R&B singer O. C. Smith. In it, a country girl dreams of riding in limos, and gets her wish in grim fashion when her party lifestyle sends her home in a hearse. As Greil Marcus observed, Elvis sang both to the girl and to himself. He knew he'd almost lost his own career through addiction to pills.

Elvis hesitated on whether he should record Mac Davis's "In the Ghetto." The message of "If I Can Dream" had been generalized, but the new song explicitly called for a helping hand to children crushed by poverty. In the end he crafted it into one of the decade's finest protest songs, and it made the Top 5 on both sides of the Atlantic.

One night, Marty recalled, "Elvis turned around and looked at me,

and it had been a long time since I had seen that look of happiness and satisfaction on his face. He said, 'Man, that felt really great. I can't tell you how good I feel.' And then he said, 'I really just want to see if I can have a number-one record one more time.'"

He found it in a single by studio staff writer Mark James, a song that brilliantly articulated the tensions that haunted Elvis's own marriage. A devastating wail of love and paranoia, the dark maturity of "Suspicious Minds" was worlds away from his soundtracks, and he was back on top of the charts for the first time since 1962.

DID YOU FIND?

1. Elvis

2. Dusty Springfield
She traveled from England to record *Dusty in Memphis* at American Sound in September 1968, an album that included "Son of a Preacher Man."

3. Roy Hamilton
One of Elvis's heroes, Hamilton was recording at American Sound the same time as Elvis was. Elvis covered his songs "I'm Gonna Sit Right Down and Cry (Over You)," "Hurt," "Unchained Melody," "I Believe," and "You'll Never Walk Alone."

4. Neil Diamond
He recorded "Brother Love's Traveling Salvation Show" before Elvis came in. Elvis covered "And the Grass Won't Pay No Mind" and the euphoric "Sweet Caroline."

5. Alex Chilton
As leader of the Box Tops, he recorded "The Letter" at American Sound. He named his next group after the local Big Star market.

6. Glen Campbell
A former Wrecking Crew session guitarist, he played on the *Viva Las Vegas* soundtrack. Campbell had also recorded "Long Black Limousine" in 1962. Elvis included his Grammy-winning 1967 hit "Gentle on My Mind" on his new album. Elvis was the top choice for 1969's *True Grit*, but his management demanded billing over John Wayne, so Campbell was given the role.

7. B. J. Thomas
"Suspicious Minds" writer Mark James also wrote B. J. Thomas's hit "Hooked on a Feeling." Another hit for Thomas, the yearning "I Just Can't Help Believin'," was perfected by Elvis in *Elvis: That's the Way It Is*.

8. Jon Voight
Director John Schlesinger offered Elvis the lead role in *Midnight Cowboy*, but the Colonel rebuffed him. Thus, Jon Voight snagged an Oscar nomination for the role, while Elvis starred in *Charro!* (1969).

9. Aretha Franklin
Chips Moman and the Memphis Boys played on the Queen of Soul's *I Never Loved a Man the Way I Love You*, and Moman cowrote "Do Right Woman, Do Right Man."

10. Mac Davis
He penned a string of hits for Elvis, including "In the Ghetto," "A Little Less Conversation," "Don't Cry Daddy," "Memories," "Charro," "Nothingville," and the protest tune "Clean Up Your Own Backyard," many cowritten with Billy Strange. He also enjoyed a successful country career and starred in films like *North Dallas Forty* (1979).

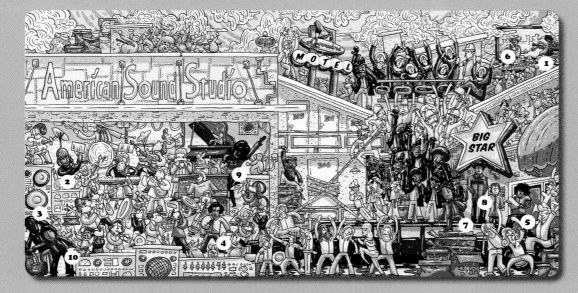

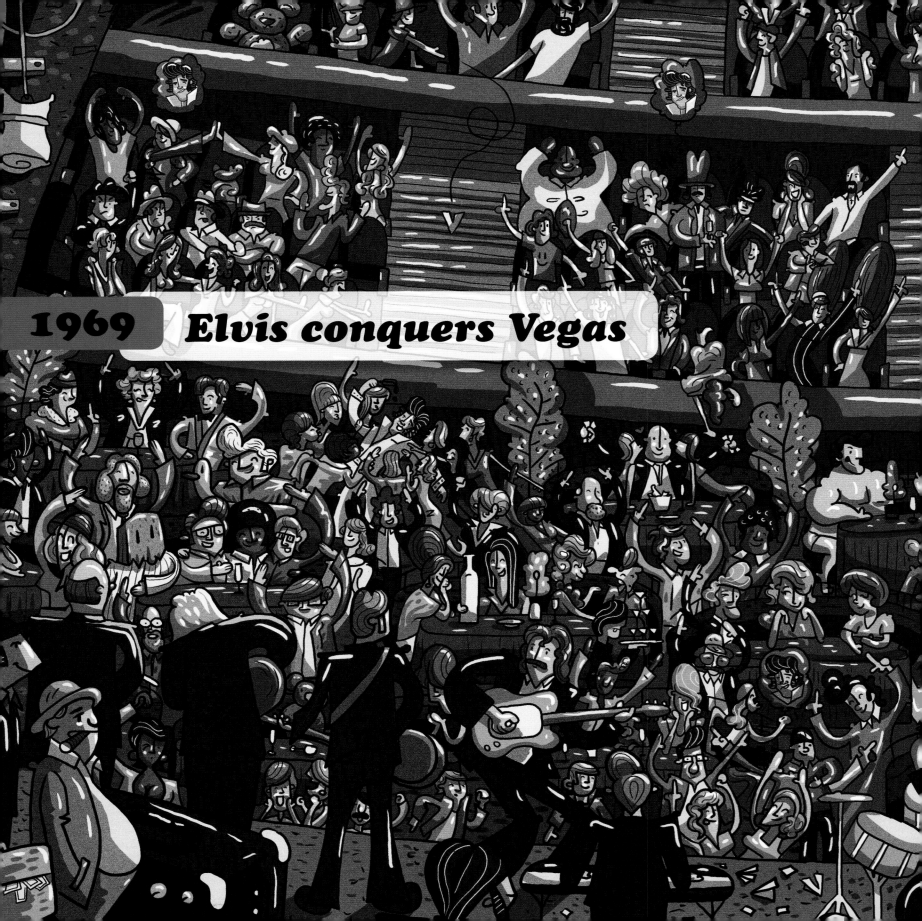

1969 Elvis conquers Vegas

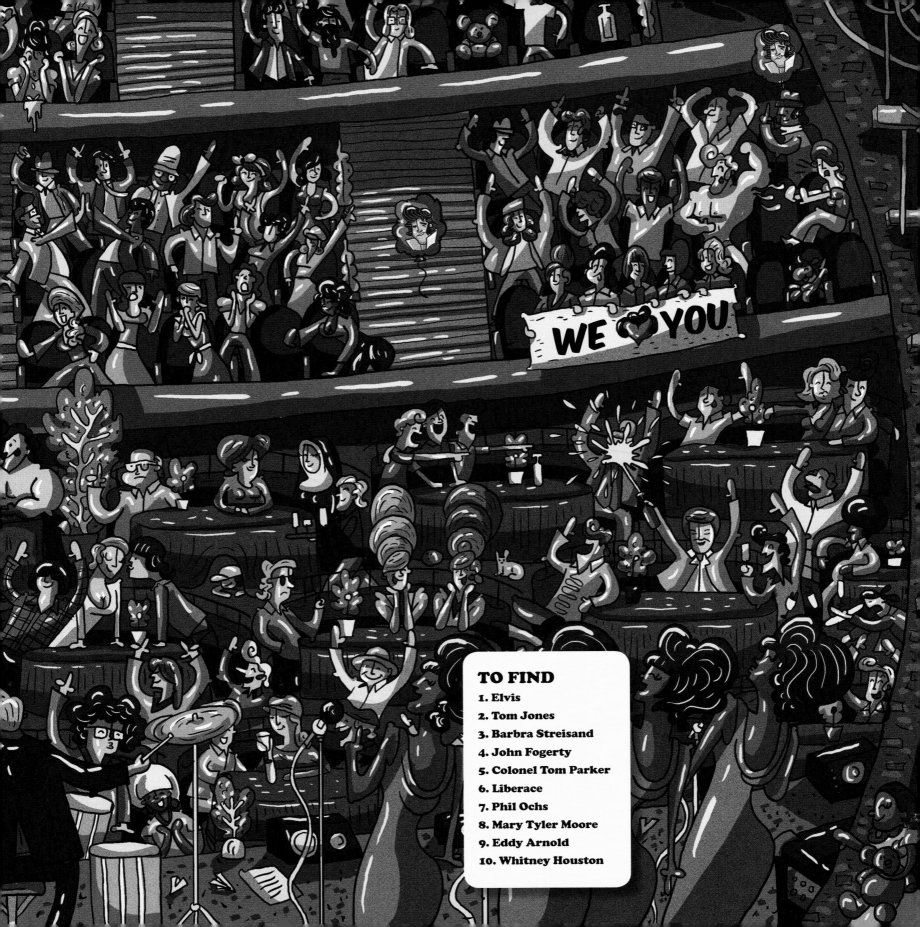

TO FIND
1. Elvis
2. Tom Jones
3. Barbra Streisand
4. John Fogerty
5. Colonel Tom Parker
6. Liberace
7. Phil Ochs
8. Mary Tyler Moore
9. Eddy Arnold
10. Whitney Houston

Elvis conquers Vegas

In the dressing room after taping the live segments of his comeback special, Elvis told the Colonel, "I want to tour again. I want to go out and work with a live audience." So the Colonel negotiated for Elvis to perform for four weeks at the new International Hotel in Las Vegas for $500,000.

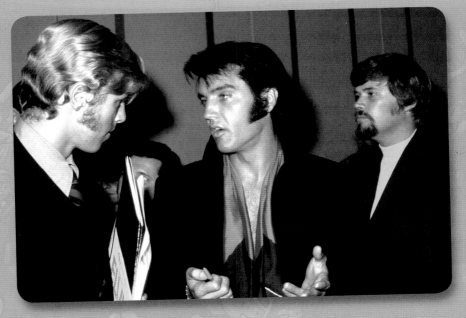

Above: Elvis gives a press conference on August 1, 1969, after his return to the stage.

Originally, Elvis asked his regular musicians and the Jordanaires to join him onstage, but all had more lucrative session work lined up. Elvis's longtime harmony singer Charlie Hodge suggested guitarist James Burton to Elvis. In the 1950s, Burton was in Ricky Nelson's band, and Elvis saw him on *The Adventures of Ozzie and Harriet*. Burton also played the riff on Dale Hawkins's 1957 single "Susie Q."

Burton recruited rhythm guitarist John Wilkinson and bassist Jerry Scheff. Elvis selected drummer Ronnie Tutt because of their instant rapport. "I emulated and accented everything that he did just instinctively," said Tutt. "Every move, almost like a glorified stripper! And he loved that."

Elvis also enlisted the black female backup group Sweet Inspirations, who had backed Aretha Franklin, Dusty Springfield, Wilson Pickett, and Van Morrison (on "Brown Eyed Girl").

All would remain with Elvis for the rest of his life. In 1970 they were joined by pianist Glen D. Hardin and Joe Guerico, who conducted the pit orchestra.

In Vegas, Elvis paired the Sweet Inspirations with the white male gospel quartet the Imperials, led by Jake Hess, who had been in Elvis's favorite gospel group the Statesmen. He also included Millie Kirkham, the female vocalist on many of his tracks going back to 1957's "Blue Christmas."

Memphis Mafia member Joe Esposito later said that he had never seen Elvis more nervous than in the hours before he returned onto the stage. Back in 1956, Elvis had performed a two-week stint at Vegas's New Frontier Hotel, and it was one of the only times he flopped live. *Newsweek* sneered he was "like a jug of corn liquor at a champagne party."

On July 31, 1969, Elvis strode onto the stage without fanfare, dressed in a black tunic, and assumed his archetypal 1950s stance—but before he could get out a word, the 2,200 audience members rose up in a thunderous ovation. He blasted through "Blue Suede Shoes," "I Got a Woman," and "All Shook Up," then shifted gears with "Love Me Tender." The climax came when he unveiled the as-yet-unreleased "Suspicious Minds." Elvis wound the song down, then

brought it pounding back multiple times. Producer Felton Jarvis recalled, "He'd be down on one knee and do a flip across the stage and just roll. He was about half crazy."

This time *Newsweek* raved, along with *Rolling Stone*, *Billboard*, and *Variety*. Possibly the greatest review came from Sam Phillips, who told Elvis he'd never heard a better rhythm section in his life.

The double album *From Memphis to Vegas/From Vegas to Memphis* included live performances from August 24–26, 1969, along with tracks left over from the American Sound Studio sessions, including the fierce "Stranger in My Own Hometown." "This is my first live appearance in nine years," Elvis quips on the record. "I've appeared dead before, but this is my first live one."

DID YOU FIND?

1. Elvis

2. Tom Jones
Elvis loved "It's Not Unusual," he studied Tom's concerts at the Flamingo Hotel, and the two singers became friends.

3. Barbra Streisand
She performed for the grand opening of the International Hotel right before Elvis arrived, and tried unsuccessfully to get him to star with her in *A Star Is Born*.

4. John Fogerty
"I'd be saying to myself, 'Gee, would Elvis do this, would he do that,'" recalled the leader of Creedence Clearwater Revival. "'No way, Elvis wouldn't do that, so I'm not.' I sort of used Elvis as my own conscience for years." Elvis covered Fogerty's "Proud Mary."

5. Colonel Tom Parker
The Colonel had tears in his eyes when Elvis hugged him after his opening-night encore. The manager lived at the International Hotel until the mid-1980s, where he lost up to a million dollars a year due to his gambling addiction.

6. Liberace
One of Vegas's most popular acts, the pianist said in 1956, "Elvis and I may be characters—he with his sideburns and me with my gold jacket—but we can afford to be." After seeing the King try on Liberace's gold jacket, the Colonel had a gold suit made for him.

7. Phil Ochs
The folk singer was so blown away by Elvis's opening-night performance that he began wearing his own gold Nudie suit in concert and on album covers. Ochs said, "If there's any hope for a revolution in America, it lies in getting Elvis Presley to become Che Guevara."

8. Mary Tyler Moore
The same month Elvis recorded "In the Ghetto," he signed on to play an idealistic doctor working in the inner city who falls in love with a nun played by Moore in *Change of Habit*. Its underrated theme song was one of the best of his socially conscious tracks, and fitted with the overhaul he was giving his career.

9. Eddy Arnold
The Colonel managed him from 1944 until 1953. Elvis sang more of his songs than any other artist, including two on *From Elvis in Memphis*.

10. Whitney Houston
The six-year-old daughter of Sweet Inspirations founder Cissy Houston was awed when Elvis walked backstage wearing mink and sunglasses. She later said, "You don't say anything. You just look. Amazing to look at. His presence was awesome."

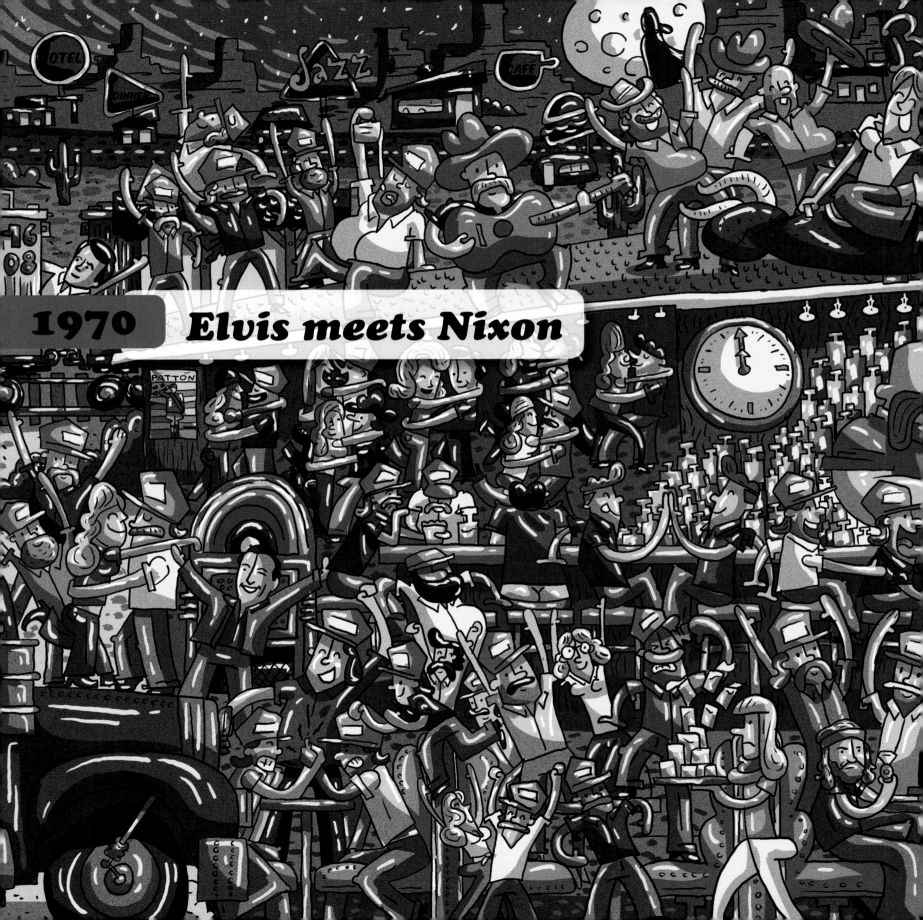

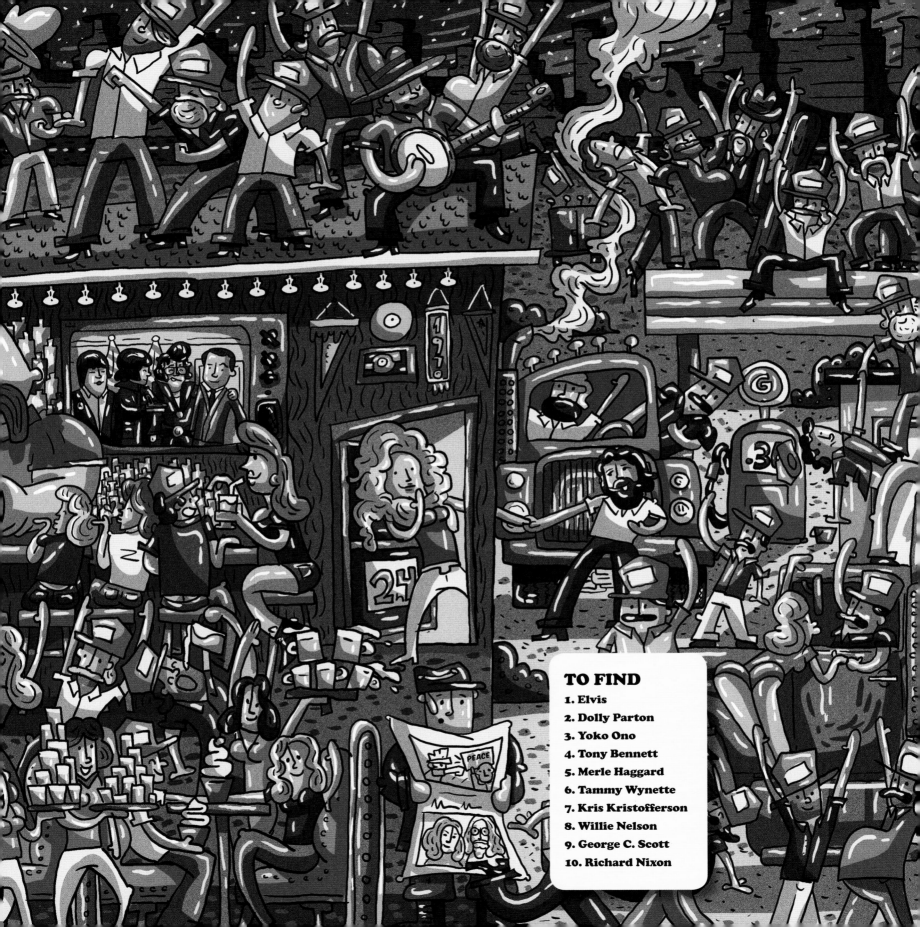

TO FIND
1. Elvis
2. Dolly Parton
3. Yoko Ono
4. Tony Bennett
5. Merle Haggard
6. Tammy Wynette
7. Kris Kristofferson
8. Willie Nelson
9. George C. Scott
10. Richard Nixon

Elvis meets Nixon

Elvis's showstopper in 1970 was "Polk Salad Annie," with lyrics that mirrored his youth as a poor boy who had to eat pokeweed while his dad was on the chain gang. And no moment that year better illustrated how far he had come than the day he got a meeting with the president arranged in just six hours.

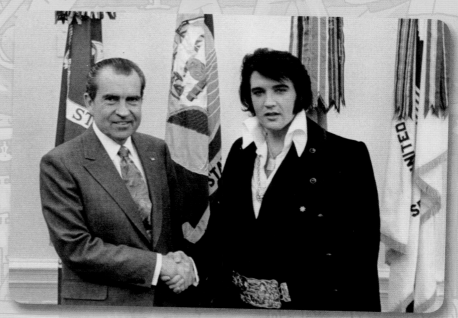

Above: Elvis asked the president to make him a "federal agent at large."

It happened because of a fight he had with his father and Priscilla over his extravagant spending habits. To cool off, he jumped on a passenger airplane for a change of scenery. Recently, he had begun collecting police badges, and on December 21 he decided to head to Washington, D.C., to try to get one from the Bureau of Narcotics and Dangerous Drugs. On American Airlines stationery, he wrote a letter to Richard Nixon explaining how he could help as a narcotics agent.

"The drug culture, the hippie elements, the SDS, Black Panthers, etc., do not consider me as their enemy or as they call it the Establishment. I call it America and I love it," he wrote. "I have done an in-depth study of drug abuse and Communist brainwashing techniques and I am right in the middle of the whole thing where I can and will do the most good."

When the plane landed, he gave all the money he had on him ($500) to a soldier returning from Vietnam, along with some jewelry. Then he dropped off the note at the gates of the White House at 6:30 a.m. Nixon's deputy counselor Egil "Bud" Krogh thought they could work with Elvis to promote antidrug messages, and at 12:30 p.m. the same day the singer was ushered into the Oval Office.

The most infamous anecdote from the singer's meeting with the president, as told to the Elvis Australia website by Krogh, was "Elvis said 'And you know, the Beatles came over here and made a lot of money and said some un-American things.'"

Perhaps Elvis was ticked because ten days earlier John Lennon had released his *Plastic Ono Band* album, in which he sang in the song "God," "I don't believe in Elvis." Or perhaps Elvis was just trying to say what Nixon (who hated Lennon) wanted to hear, because right afterward, according to Krogh, he asked the president for the badge.

"And the president looked and he said, 'Bud, can we get him a

badge?' And I said, 'Well, Mr. President, if you want to get him a badge, we can do that.' He said, 'Well, get him a badge.' Well, Elvis was so happy about this, he steps around the side of the desk and he goes over and he grabs him . . . [and hugs] Richard Nixon, who's sort of standing there looking up, thinking, 'Oh, my God!' "

Nixon opened his desk to give souvenirs to the two bodyguards Elvis brought with him. Krogh recalled, "Well, Elvis just sensed that there was a lot of stuff in that drawer. So he went behind the desk and, as the president is taking out the cuff links and the paperweights and the golf balls, Elvis is reaching in toward the back of the drawer and taking out the real gold stuff, the valuable presents . . . he says, 'Mr. President, they have wives.' "

DID YOU FIND?

1. Elvis

2. Dolly Parton
She covered "In the Ghetto" in 1969 but wouldn't let Elvis cover "I Will Always Love You" when his management tried to get her to give up half her royalties. Elvis never went back to American Sound Studio because of a similar fight over "Suspicious Minds."

3. Yoko Ono
Her book *Grapefruit* inspired John Lennon's "Imagine," and her experience with performance art inspired the couple's antiwar "Bed-Ins" and "Give Peace a Chance," which led to Nixon's determination to deport Lennon from the States.

4. Tony Bennett
The Italian crooner scored a number-one hit with Hank Williams's "Cold, Cold Heart" in 1951, exposing country music to a wider audience. Elvis tackled Bennett's "Rags to Riches" in 1971.

5. Merle Haggard
The Bakersfield country star released an album of Elvis songs called *My Farewell to Elvis* in 1977, which included his own "From Graceland to the Promised Land."

6. Tammy Wynette
Her 1968 songs "Stand by Your Man" and "D-I-V-O-R-C-E" resonated as the Sexual Revolution and women's liberation inaugurated an era of skyrocketing divorce rates, which Elvis would soon confront in his own songs like "Separate Ways."

7. Kris Kristofferson
Elvis recorded the outlaw country singer-songwriter's "Help Me Make It Through the Night," "Why Me Lord," and "For the Good Times." Kris took the part opposite Barbra Streisand in 1976's *A Star Is Born* after Elvis turned it down.

8. Willie Nelson
Elvis sang Nelson's "Funny How Time Slips Away" on *Elvis Country (I'm 10,000 Years Old)*. Fans argue over who recorded the most definitive versions of "Always on My Mind" and "Blue Eyes Crying in the Rain."

9. George C. Scott
Elvis memorized his lines from *Patton* (1970).

10. Richard Nixon
When the formal pictures were taken, Nixon considered Elvis's purple cloak, shades, cane, and huge gold belt (a gift from the International Hotel) and said, "You dress kind of strange, don't you?" "Well, Mr. President," said Elvis, "you got your show, and I got mine." Years later in 1974, when Nixon was hospitalized for phlebitis, Elvis called him. A year later, Nixon returned the favor when Elvis was in the hospital for colon and liver problems.

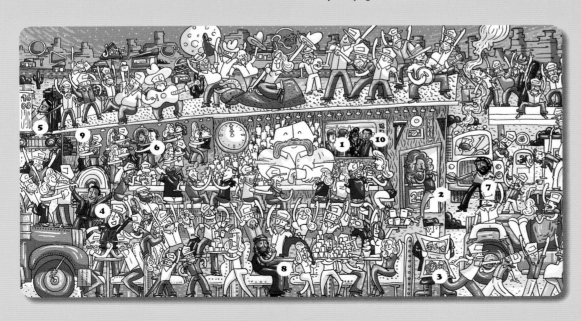

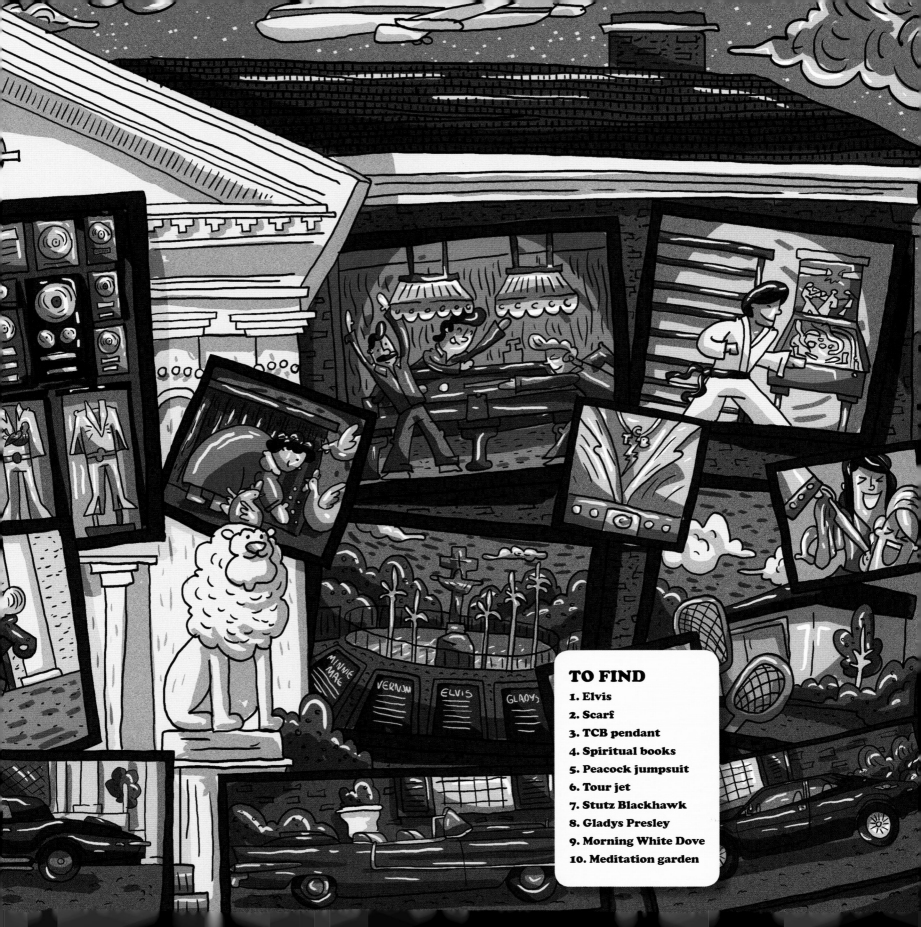

TO FIND

1. Elvis
2. Scarf
3. TCB pendant
4. Spiritual books
5. Peacock jumpsuit
6. Tour jet
7. Stutz Blackhawk
8. Gladys Presley
9. Morning White Dove
10. Meditation garden

"Talk About the Good Times"

At the start of the seventies, Elvis found himself in the midst of a renaissance, and he often hung out at the gates of Graceland signing autographs and taking pictures with the fans, sometimes bringing them inside. In Vegas he tossed scarves to the audience, kissed women in the front row, and occasionally walked into the crowd.

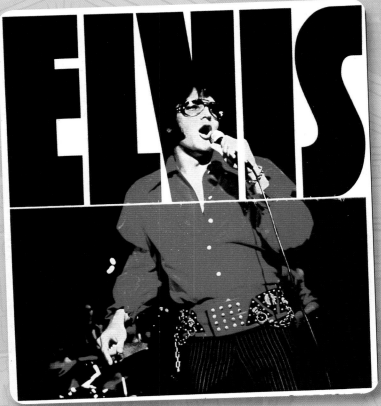

Above: Film poster for Elvis: That's the Way It Is *(1970).*

His new band reinvigorated him with its more contemporary sound, with tougher guitar, pulsating bass, and powerful horns. Bassist Jerry Scheff said, "For the first couple of years he almost demanded that we kick him in the butt." *On Stage* (recorded February 15–19, 1970) featured his best rockers of the decade, including "Walk a Mile in My Shoes," the last of his string of topical songs preaching tolerance. In contrast to the soundtrack era, many of his songs were stories rich in cinematic detail, such as his 50th gold record, "Kentucky Rain."

The feature *Elvis: That's the Way It Is* captured him live in August 1970, resplendent in bell-bottom jumpsuit with high Napoleonic collar. It was white so that lights could be projected onto him, and looser than his TV leather outfit so that he could add karate moves to his pile-driving pelvic thrusts. He was still hungry and, having been performing live for a year, as loose and limber as Mick Jagger. The film caught his peak, gliding his shoulders and shaking with abandon, yet

poking fun at himself. In "You've Lost That Lovin' Feelin'" he sang, "Baby, I get down on my knees for you—*if this suit wasn't too tight!*"

During a five-night Nashville session in June, he recorded 34 songs and split them into the pop *Elvis: That's the Way It Is* album and *Elvis Country*, both among his best. "Stranger in the Crowd" was a rousing sketch of love at first sight by Winfield Scott, cowriter with Otis Blackwell of many of Elvis's hits. "The Next Step Is Love" combined Beatles-inspired trumpets and cellos with wah-wah guitar.

He continued to push himself in 1971 with the desolate acoustic guitar and eerie Orbison-like moans of "I'm Leavin'." "Phew man, it's tough," he said, "but the thing is worth working on." Venturing deeper into folk, he sang Gordon Lightfoot's "Early Morning Rain" with a new voice, quietly wistful and without affectation, along with songs by Dylan and Buffy Sainte-Marie. The epic medley "An American Trilogy" strove to represent all sides of the Civil War: the

Confederacy through the blackface minstrel song "Dixie," the Union with the marching song "The Battle Hymn of the Republic," and African Americans with "All My Trials," a Bahamian lullaby.

A month after he recorded "Trilogy," he knocked off one of his greatest rock anthems without even trying. "Burning Love" was blocked from the top of the charts only by Chuck Berry's ignominious "My Ding-a-Ling." The 1972 documentary *Elvis on Tour* featured split-screen montages edited by *Woodstock* alumnus Martin Scorsese, and it won the Golden Globe. His sold-out Madison Square Garden shows earned raves from the *New York Times*, and the live album went triple platinum. Side two opened with "The Impossible Dream," but there didn't seem to be any that were impossible for him.

DID YOU FIND?

1. Elvis

2. Scarf
In concerts, Elvis wiped his sweat with scarves and gave dozens to fans during each show.

3. TCB pendant
On October 19, 1970, Priscilla helped Elvis design the "Taking Care of Business" necklaces for his entourage. It was a popular catchphrase (Aretha sings it in "Respect"), and the lightning bolt was the symbol of his favorite comic hero, Captain Marvel; his army battalion; and the West Coast (real) Mafia. He put the logo on rings, belts, sunglasses, necklaces, the *Lisa Marie* jet—and it eventually graced his tombstone. TLC "Tender Loving Care" pendants were for female friends and family.

4. Spiritual books
Elvis always carried several on tour. His favorites were *The Impersonal Life* (1914) by Joseph Sieber Benner and *The Prophet* (1923) by Kahlil Gibran.

5. Peacock jumpsuit
Costume designer Bill Belew created Elvis's leather outfit for the comeback special, then jumpsuits like karate gis starting in 1969. Gene Doucette handled the embroidery, then took over from Belew in 1972. Elvis had approximately 120, and wore them on 22 album covers during his lifetime. He wore the peacock jumpsuit on *Promised Land*'s cover. It sold for $300,000 in 2008.

6. Tour jet
Elvis loved buying planes to tour on—eight in all, including the customized *Lisa Marie*.

7. Stutz Blackhawk
Elvis owned the very first in 1970, and the 1973 model was his favorite car. His addiction to giving away autos was legendary. In 1975, bank teller Mennie Person was window shopping at the Cadillac dealership when Elvis was there. After she complimented his limo, he bought her an Eldorado.

8. Gladys Presley
After Elvis bought Graceland in March 1957, his mother had a chicken coop built out back and relaxed by feeding the birds.

9. Morning White Dove
Elvis was primarily Scottish, Irish, Welsh, German, and French—but his maternal great-great-great grandmother was Jewish and her mother was a Cherokee named Morning White Dove. Thus Elvis was excited to don dark makeup to play a Native American in *Flaming Star* (1960).

10. Meditation garden
Elvis built it at Graceland to evoke the Self-Realization Fellowship center. After grave robbers planned to break into his mausoleum at the Forest Hills Cemetery, he and his mother were reburied here on October 2, 1977. Elvis's father and grandmother, Minnie Mae ("Dodger"), later joined them, and a memorial was added for his brother, Jessie Garon.

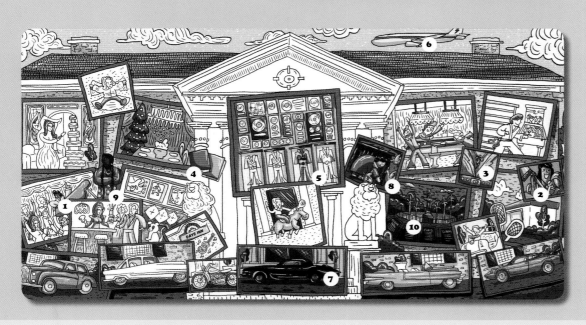

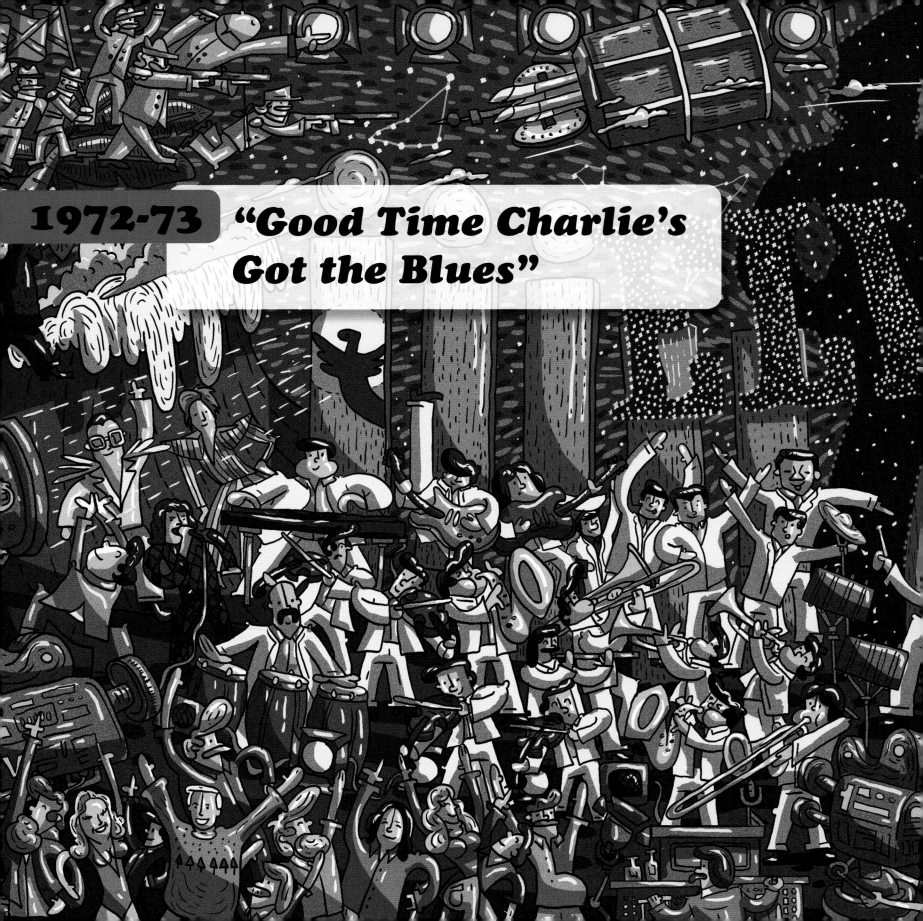

1972-73 *"Good Time Charlie's Got the Blues"*

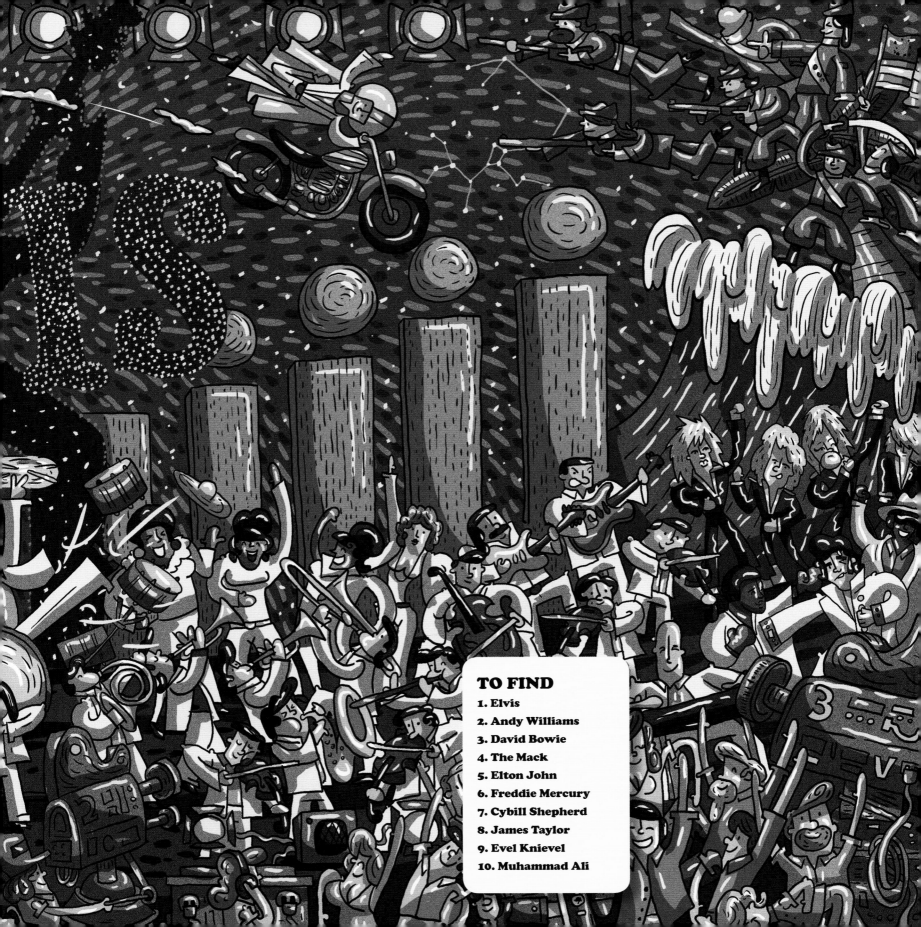

TO FIND

1. Elvis
2. Andy Williams
3. David Bowie
4. The Mack
5. Elton John
6. Freddie Mercury
7. Cybill Shepherd
8. James Taylor
9. Evel Knievel
10. Muhammad Ali

"Good Time Charlie's Got the Blues"

Above: Elvis and Priscilla leave the courthouse following their divorce, October 9, 1973.

Elvis's soundtracks had often celebrated a cartoonish Don Juan lifestyle, but recent tracks like "You'll Think of Me" and "Inherit the Wind" began to express weariness at its cost. Still, he didn't change his ways, so Priscilla asked for a divorce, and they separated on February 23, 1972.

On March 27, he went into the studio and recorded a song cowritten by Memphis Mafia member Red West, Elvis's friend and protector since high school. "Separate Ways" conveyed a father's sadness at how his crumbling marriage affected his young child. Its flip side, "Always on My Mind," was another classic of regret, cowritten by Mark James, and voted Elvis's best in a 2013 poll by Britain's ITV viewers. "Man, you're killing me with these songs," Elvis said.

Soon he recorded enough tracks about broken homes to rival Dylan's *Blood on the Tracks*. His canon now equaled Sinatra's for songs of failed relationships to be played on jukeboxes in the wee small hours—only in a country bar instead of a New York saloon: "Don't Cry Daddy," "I've Lost You," "It's Only Love," "Loving Arms," "For the Good Times," "Pieces of My Life," "It's Easy for You," "My Boy,"

"Fool." ("Fool" was a word that increasingly cropped up in the lyrics he chose.)

In the 1960s, when he sang that he had no reason left to live, listeners knew he didn't really mean it. But Elvis told his friend Larry Geller that 1972 was his worst year since 1958—the year he lost his mother and got drafted. As U2's Bono said, "The big opera voice of the later years—that's the one that really hurts me."

Less than two years previously, in *Elvis: That's the Way It Is*, he was kinetic and impossibly cool. But in *Elvis on Tour*, shot in the March and April after the separation, he was sedate, no longer wildly swaying. He was jowly, pale, sweaty, and looked depressed. Indeed, the film included the recording session of "Separate Ways."

With mutton chops, huge gold belt buckle, and big amber

sunglasses, he had arrived at his last incarnation, the one Elvis impersonators favored because it was easy to do. The karate moves and outstretched cape suddenly seemed a touch goofy.

But in a strange way, this was his most lovable incarnation of all, because now he was no longer untouchable, but vulnerable. And when the film showed him finding solace by singing gospel with his friends the way he had always done, it underscored how he had always been about much more than his looks. And his voice was as strong as ever.

Eight months later, he lost 25 pounds, got a more flattering haircut, and gave the world's first globally telecast live concert on January 14, 1973, seen by 1.5 billion people. The album, *Aloha from Hawaii via Satellite*, became his first number one since 1964's *Roustabout*. The set list included "You Gave Me a Mountain," about a man devastated when his wife leaves and takes their child, but as he thundered through it in his gem-studded American Eagle suit, it seemed even a mountain couldn't stop the King.

DID YOU FIND?

1. Elvis

2. Andy Williams
Elvis thought he had the "greatest pipes" of any white singer. Williams started out singing backup for Bing Crosby, and had his own TV variety show from 1962 to 1971, during which time he sold more records than any solo artist except Frank Sinatra, Johnny Mathis, and Elvis.

3. David Bowie
"He was a major hero of mine," Bowie said of Elvis. "And I was probably stupid enough to believe that having the same birthday as him actually meant something." Some say Bowie's Aladdin Sane makeup was inspired by Elvis's TCB lightning bolt insignia. Bowie told Dwight Yoakam that Elvis called him after hearing "Golden Years" and asked him to produce his next record, but that Elvis passed away before it could happen.

4. The Mack
Elvis bought the white limo from the blaxploitation film *Shaft*, and some of his 1970s outfits didn't seem far removed from those worn by pimp daddies in movies like *The Mack* (1973).

5. Elton John
"It was Elvis that got me interested in music. I've been an Elvis fan since I was a kid. Ask anyone. If it hadn't been for Elvis, I don't know where popular music would be. He was the one that started it all off, and he was definitely the start of it for me."

6. Freddie Mercury
The lead singer of Queen wrote "Crazy Little Thing Called Love" as a tribute to Elvis.

7. Cybill Shepherd
The star of *The Last Picture Show*, *Taxi Driver*, and *Moonlighting* dated Elvis briefly in the early 1970s.

8. James Taylor
Elvis's performance of his "Steamroller Blues" in the *Aloha* special made it to number 17 on the pop chart.

9. Evel Knievel
The daredevil motorcyclist wore white jumpsuits with American stars and a cape. "I guess I thought I was Elvis Presley, but I'll tell ya something. All Elvis did was stand on a stage and play a guitar. He never fell off on that pavement at no 80 mph."

10. Muhammad Ali
"Elvis was my close personal friend. He came to my Deer Lake training camp about two years before he died," the boxer said. "I don't admire nobody, but Elvis Presley was the sweetest, most humble and nicest man you'd want to know."

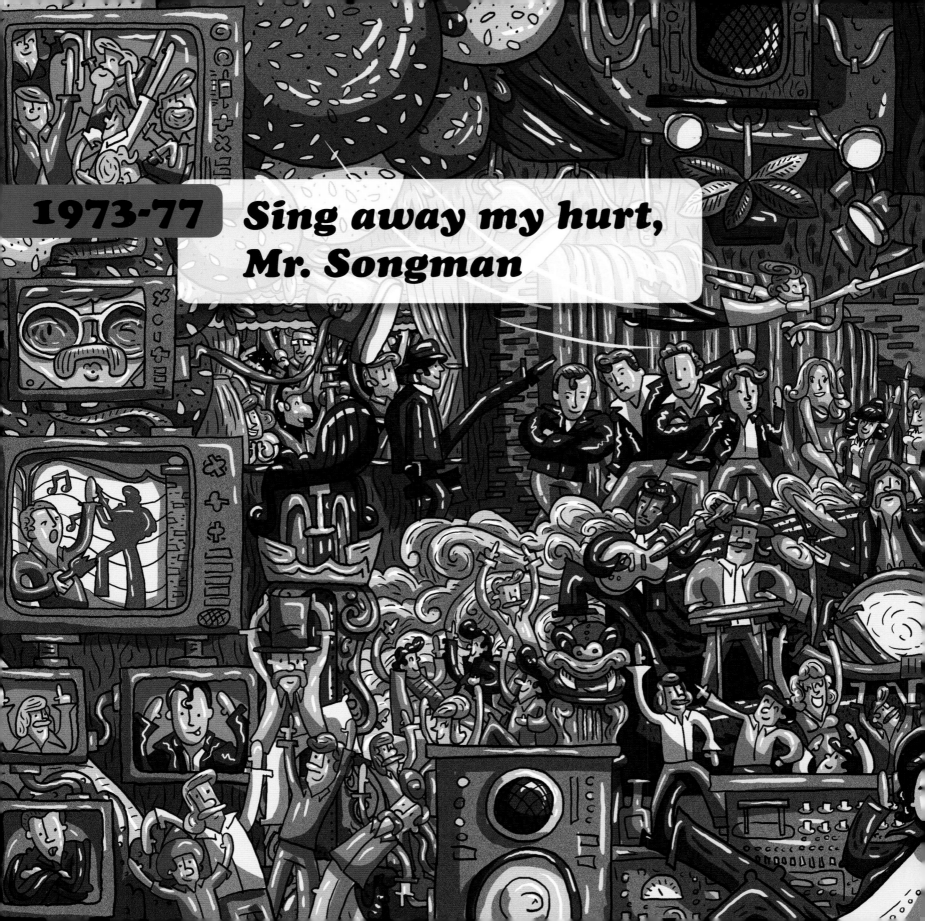

1973-77

Sing away my hurt, Mr. Songman

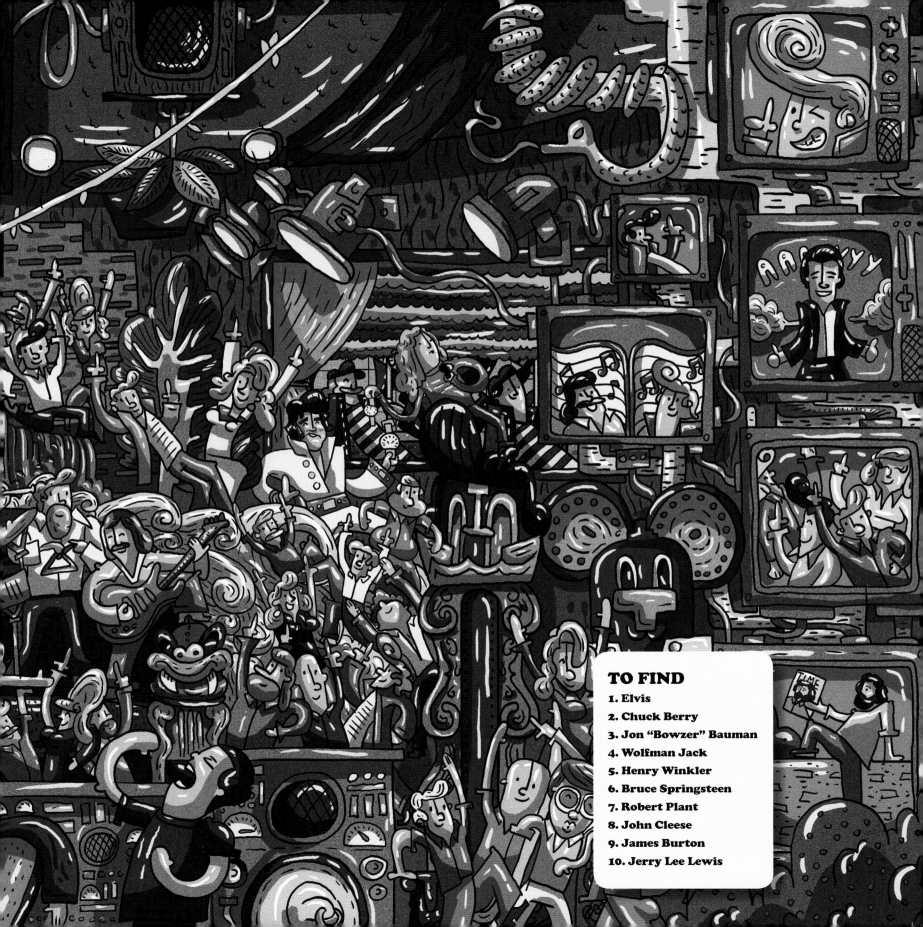

TO FIND

1. Elvis
2. Chuck Berry
3. Jon "Bowzer" Bauman
4. Wolfman Jack
5. Henry Winkler
6. Bruce Springsteen
7. Robert Plant
8. John Cleese
9. James Burton
10. Jerry Lee Lewis

Sing away my hurt, Mr. Songman

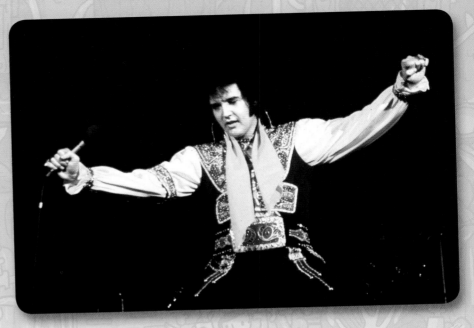

Above: Elvis onstage in Asheville, North Carolina, July 23, 1975.

Elvis played 1,152 shows between July 31, 1969, and June 26, 1977. His biggest concert took place on New Year's Eve 1975, at the Detroit Silverdome, where he brought in 60,000—not far behind the 76,000 drawn by Led Zeppelin, the Who, and Aerosmith during the era.

In many respects he was more of a country act by now. After "Are You Lonesome Tonight" in 1960, he had disappeared from the country charts until 1968, when "U.S. Male" made it to country 55, but by 1973 he was doing better in country than pop. In his last decade he had nine Top 10 country singles and five number-one country albums. He also had 16 Top 10 easy listening hits, and he stands as the biggest seller in adult contemporary after Elton John, Barbra Streisand, and Neil Diamond.

During his 1973 sessions at Stax Records, he was sometimes bathed in wah-wah funk, like bands such as the Rolling Stones were at the time. The sunny "I've Got a Thing About You Baby" was an essential single, written by Tony Joe White (of "Polk Salad Annie" fame), and he scored Top 20s with the divorce anthem "My Boy" and Chuck Berry's "Promised Land." The latter was a barreling successor to "Guitar Man" that celebrated the touring lifestyle, and affords an interesting opportunity to compare Elvis's 1973 band doing a Berry tune with his 1963 band doing Berry's "Memphis."

"Thinking About You" matched a singer-songwriter/soft rock acoustic sound with a touching vocal fragility. And "Good Time Charlie's Got the Blues" held as dark a prophecy as "Long Black Limousine" with the lines "Play around you lose your wife/ play too long, you lose your life."

In 1976 he moved recording equipment into Graceland and held sessions in his den, nicknamed the Jungle Room. "Hurt" was a bravura tightrope walk between overwrought melodrama, tongue-in-cheek Bert Lahr self-parody, and soaring vocal pyrotechnics. Listening to it and other tracks like "Fool" and "First Time Ever I Saw Your Face," you can hear where superfan Morrissey learned to revel in melancholic yodeling.

Mark James contributed the country disco sparkler "Moody Blue."

"Way Down" was cut during his last session on October 29. Later the title and lyrical references to medicine, spinning heads, and prescribing doctors took on a grimmer resonance. But the band rocked joyfully, and Elvis also sounded like he was having fun on the live "Little Darlin'" included on the *Moody Blue* album.

The same good humor was apparent in the June 1977 performances captured in the CBS television special *Elvis in Concert* and the documentary *This Is Elvis*. His outfit was too tight, he didn't move like he used to, and he sometimes flubbed lyrics, as in the spoken-word section of "Are You Lonesome Tonight." But that was part of his shtick, and many fans loved it when he'd riff, "And the stage is bare, and I'm standing there, without any hair—ahh no!"

He introduced his dad to the crowd, and sang "Hurt" to his girlfriend Ginger Alden. He could still belt "It's Now or Never" and "How Great Thou Art" at full power, and his warm smile still lit the auditorium.

DID YOU FIND?

1. Elvis

2. Chuck Berry
Elvis sang the poet laureate of rock's anthems "Johnny B. Goode," "Memphis," "Too Much Monkey Business," and "Promised Land."

3. Jon "Bowzer" Bauman
After the tumultuous 1960s, many yearned for simpler times, sparking a 1950s revival. Bowzer and his fellow Sha Na Na bandmates spoofed the period at Woodstock and on their TV show, some wearing gold lamé jackets.

4. Wolfman Jack
After the raspy DJ's star turn in George Lucas's *American Graffiti* (1973), he also got his own variety show.

5. Henry Winkler
When ABC turned *American Graffiti* into *Happy Days*, they plucked Winkler out of *The Lords of Flatbush* to play the Fonz.

6. Bruce Springsteen
He hopped the walls of Graceland to meet the King, but Elvis was in Lake Tahoe. He adapted the lyrics of "King of the Whole Wide World" into "Badlands," and other Elvis-inspired compositions included "Pink Cadillac," "Johnny Bye Bye," and "Come On (Let's Go Tonight)."

7. Robert Plant
When Led Zeppelin met the King, Jimmy Page told him that Plant only wanted to sing Elvis songs like "Love Me" at their sound checks. When Plant was leaving, he recalled, "I was walking down the corridor. [Elvis] swung 'round the door frame, looking quite pleased with himself, and started singing that song: 'Treat me like a fool…' I turned around and did Elvis right back at him. We stood there, singing to each other."

8. John Cleese
Elvis and his friends would pass time reciting their favorite lines by Cleese's comedy troupe, Monty Python.

9. James Burton
Elvis's axe man created his unique "chicken pickin'" style by using banjo strings for the top four strings of his Telecaster and employing both a flat pick and a finger pick.

10. Jerry Lee Lewis
Elvis covered the fellow Sun artist's "Whole Lotta Shakin' Goin' On" in 1971. On November 22, 1976, the King invited the Killer to Graceland, but when he arrived Elvis was already asleep, so the pianist drove off and flipped over his Rolls Royce. Twenty-four hours later he showed up again, plastered. His nose was cut and his window was smashed because he had just tried to throw a champagne bottle out of the car with the window rolled up. "I don't wanna talk to that crazy son of a —" Elvis told the guards over the intercom. When the cops arrived and Jerry opened the car door, his pistol fell on the floorboard and he was arrested.

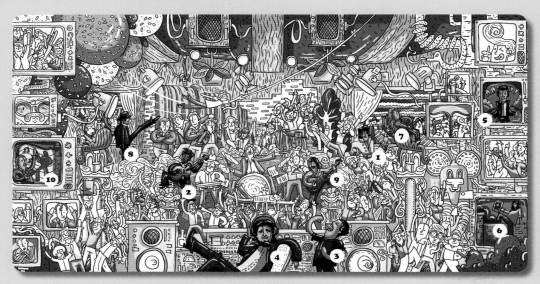

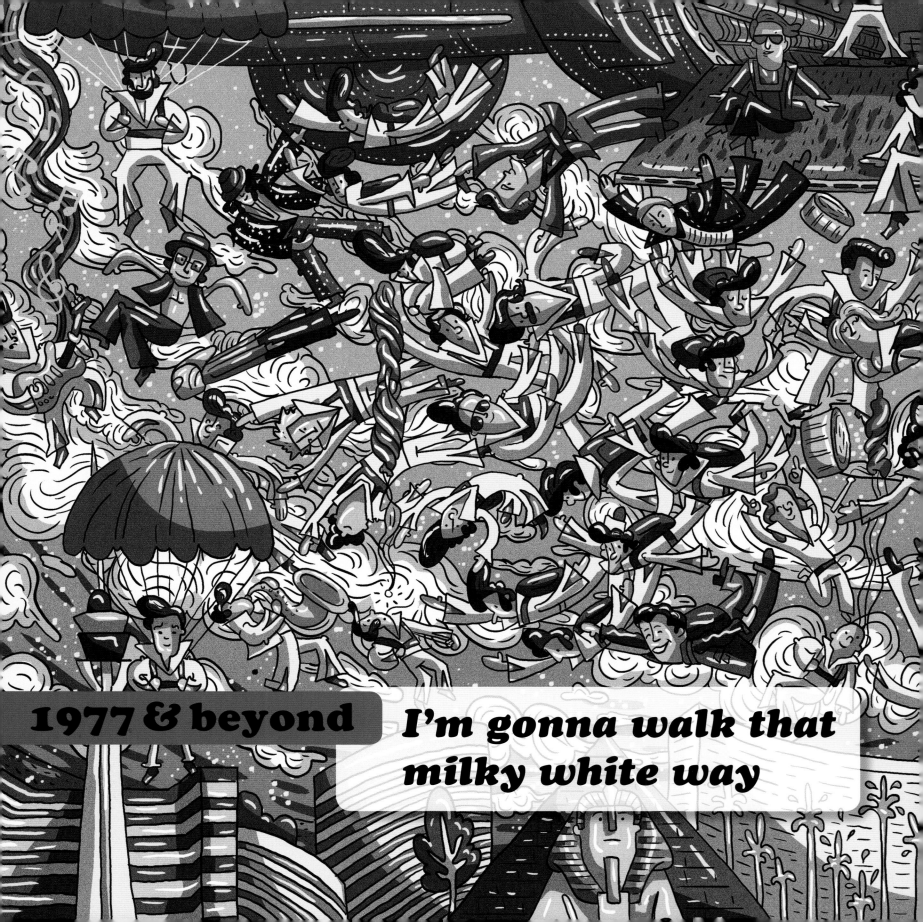

1977 & beyond

I'm gonna walk that milky white way

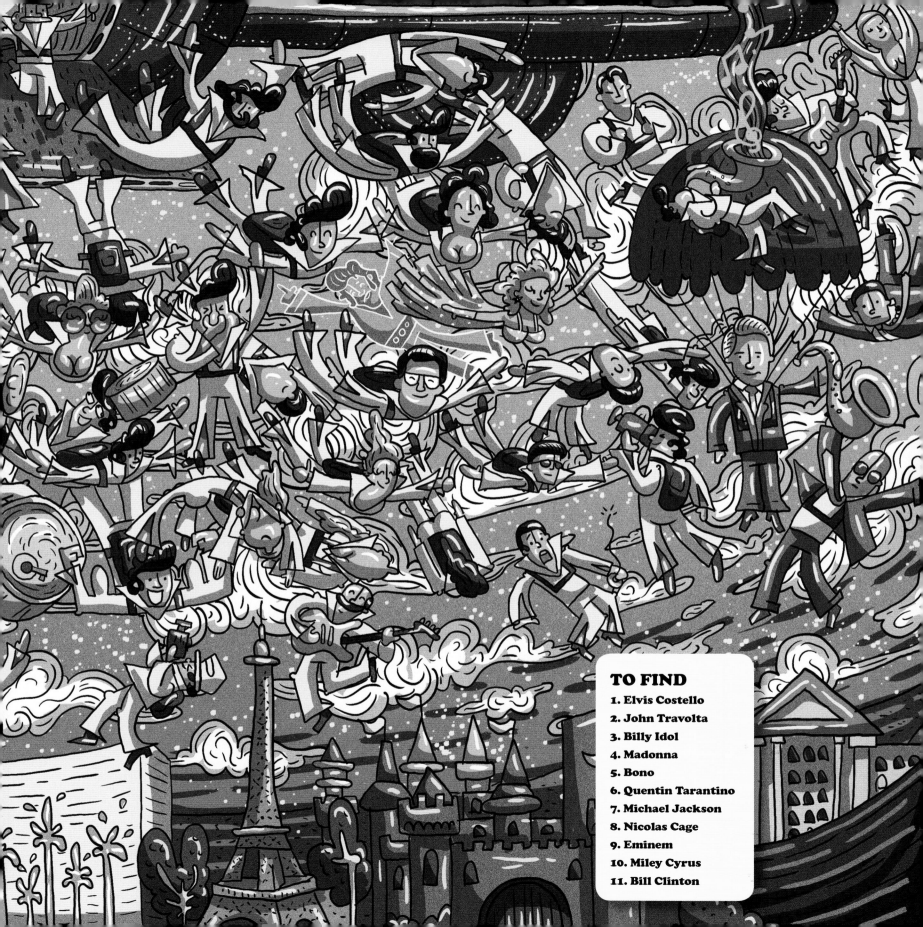

TO FIND
1. Elvis Costello
2. John Travolta
3. Billy Idol
4. Madonna
5. Bono
6. Quentin Tarantino
7. Michael Jackson
8. Nicolas Cage
9. Eminem
10. Miley Cyrus
11. Bill Clinton

Left: An estimated 50,000 gathered outside Graceland following Elvis's death.

I'm gonna walk that milky white way

On August 16, 1977, Elvis was found on his bathroom floor in Graceland, and paramedics were unable to revive him. Dependence on amphetamines, sleeping pills, and painkillers had contributed to an enlarged heart, colon, liver, and arteriosclerosis. He was 42 years old. His mother also died young, at 46, nine years earlier.

The following day President Jimmy Carter, Elvis's sixth cousin once removed, issued a statement that the singer "permanently changed the face of American culture" and "was a symbol to people the world over of the vitality, rebelliousness, and good humor of his country."

Florists FTD told CBS that they delivered the most floral arrangements in their history (3,116), many in the shapes of guitars, hound dogs, and lightning bolts. "I put Elvis in his first suit and I put him in his last," said Beale Street clothier Bernard Lansky; he dressed him in a white suit with blue shirt and tie. Family and friends viewed the body, including Ann-Margret, Caroline Kennedy, Sammy Davis, Chet Atkins, and James Brown, then Vernon allowed the fans to see Elvis one last time. They entered Graceland four at a time, 20,000 in all, a few fainting in the 90-degree heat, some having driven from Indiana, Wisconsin, and Colorado. On August 18, police escorts led the white hearse, followed by 17 limousines, to Forest Hill Cemetery.

On June 7, 1982, Priscilla opened Graceland to the public, to raise money to cover operating expenses and property taxes. Elvis tribute artists flourished: El Vez, Elvis Herselvis, Black Elvis, Lady Elvis, Dread Zeppelin's Tortelvis, Andy Kaufman (Johnny Cash said he was Elvis's favorite), Disney's Stitch, and most successful of all—captured at age four in the 1990 documentary *Viva Elvis*—Bruno Mars.

In 1988 Michigan's *Kalamazoo Gazette* reported that a mother and her daughter spotted the King ordering a Whopper in Burger King, and the inverse of the "Paul Is Dead" craze swept the media. Bill Bixby investigated in *The Elvis Files* (1991) and *The Elvis Conspiracy* (1992). Also in 1992, two million voted on whether a stamp should feature the 1950s or 1970s Elvis—the younger version won.

There were many TV movies and miniseries, with three holding up strongly: a 1979 telecast starring Kurt Russell, a 1990 series starring Michael St. Gerard, and a 2006 miniseries, for which Jonathan Rhys

Meyers won the Golden Globe. The documentaries *This Is Elvis* (1981) and *Elvis By the Presleys* (2005) remain essential viewing.

Even now Elvis periodically tops the charts. A 2002 remix of "A Little Less Conversation" hit No. 1 in the UK, as did three reissued singles and the 2015 album *If I Can Dream. ELV1S: 30 #1 Hits* (2002) conquered both sides of the Atlantic.

After *Forbes* began reporting their list of top-earning dead celebrities in 2000, Elvis headed the list every year but two for a decade, and today is second only to Michael Jackson. Graceland is the second most-visited home in the States after the White House.

Elvis's spot in history books is secure for daring to smash through the walls of segregation and repression. But it is for his over 700 songs that fans continue to love him. Just when you think you've heard them all, there is a new jewel to discover from (as Dylan called him) "the powerful, mystical Elvis that crash-landed from a burning star onto American soil."

DID YOU FIND?

1. Elvis Costello
Declan McManus changed his name before his first single "Less than Zero" in March 1977.

2. John Travolta
The actor/dancer synthesized his style with the King's in *Grease* (1978).

3. Billy Idol
Sid Vicious appropriated Elvis's sneer, mangled "My Way," then self-destructed. Billy took Sid's look and the sneer.

4. Madonna
Born on the same date Elvis died (August 16), she did her best to stir Elvis-scale controversy on behalf of the women, starting by rolling around on the ground in a wedding dress on the 1984 MTV Music Awards singing "Like a Virgin."

5. Bono
U2 recorded "Elvis Presley and America" as a reaction to Albert Goldman's unflattering Presley bio. A few years later they went to Sun Records and recorded with B. B. King.

6. Quentin Tarantino
He played an Elvis impersonator on *The Golden Girls* and included an Elvis apparition in *True Romance* (1993).

7. Michael Jackson
The King of Pop married the King of Rock's daughter Lisa Marie on May 26, 1994. They divorced on August 20, 1996.

8. Nicolas Cage
He sang Elvis songs as an Elvis-like rebel in *Wild at Heart* (1990), dived out of a plane with Elvis impersonators in *Honeymoon in Vegas* (1992), then married Lisa Marie on August 10, 2002. They divorced on November 25 that year.

9. Eminem
Growing up in a predominantly black neighborhood, he internalized hip-hop at an early age and was the cute white star needed to complete the genre's takeover from rock and roll in the hearts of suburban youth . . . like what Elvis did to big-band music.

10. Miley Cyrus
After causing parental outrage for twerking on the 2013 MTV Music Awards, she wore a white Elvis jumpsuit and stated, "Elvis, he wasn't wearing the outfits I was wearing but he was coming out and he was doing like the OG twerking. Like, no one wants to admit that he was twerking, he was."

11. Bill Clinton
It was a bold move for the presidential candidate to appear on *The Arsenio Hall Show* in June 1992 and play "Heartbreak Hotel" on his sax in his shades, but it paid off.

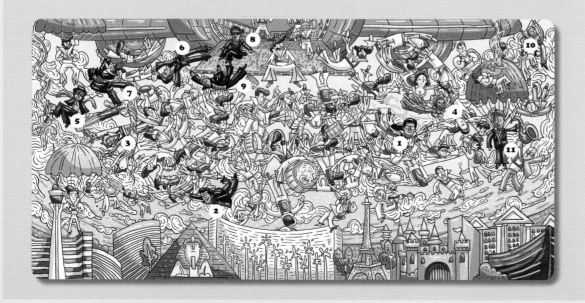

Where's Elvis?
Timeline

Pre 1950s

January 8, 1935
Elvis Aron Presley is born in Tupelo, Mississippi, to Vernon Elvis Presley and Gladys Love Presley. His twin brother Jessie Garon is stillborn.

1946
Elvis sings on the local radio show of Mississippi Slim, "The Singin' and Pickin' Hillbilly."

1950s

Summer 1953
Elvis pays $3.98 to have Marion Keisker of the Memphis Recording Service (a.k.a. Sun Records) make a demo of him singing "My Happiness" and "That's When Your Heartaches Begin." Marion makes a note that he is a good ballad singer.

January 1954
Elvis returns to Sun to record another demo, "I'll Never Stand in Your Way" and "It Wouldn't Be the Same Without You."

July 5, 1954
Elvis records his first A-side, "That's All Right."

July 17, 1954
Elvis, Scotty Moore, and Bill Black play their first live gig at the Bon Air Club in Memphis.

1954, live performances
Scotty Moore's Web site says the trio played 45 gigs during the year. (Source: www.scottymoore.net/tourdates50s)

May 13, 1955
Elvis sparks his first riot. In Jacksonville, Florida, when Elvis tells the audience, "Girls, I'll see you all backstage," the fans burst through the police and chase Elvis into the locker room, ripping off his coat, shirt, belt, and socks to take as souvenirs, before he manages to take refuge on top of the showers.

October 1955
Elvis opens for Bill Haley, who is touring behind "Rock Around the Clock," the first rock single to top the pop chart.

1955, live performances
Scotty Moore's Web site lists 277 gigs for the year.

January 28–March 24, 1956
Elvis makes six appearances on the television program *Stage Show.*

May 1956
Journalist Robert Johnson of the *Memphis Press Scimitar* dubs Elvis "the fledgling king of rock 'n' roll."

April 3 and June 5, 1956
Elvis appears on *The Milton Berle Show.*

July 1, 1956
Elvis appears on *The Steve Allen Show.*

Summer 1956
Journalist Pinckney Keel of Mississippi's *Clarion Ledger* brands the singer "Elvis the Pelvis."

September 9, 1956
Sixty million viewers tune in to Elvis's first appearance on *The Ed Sullivan Show*, 82.6 percent of the TV audience. It is the most-watched program in television history at the time. (He returns to the show on October 28, 1956, and January 6, 1957.)

1956, live performances
Scotty Moore's Web site lists 119 gigs for the year.

1957
"All Shook Up" and "Jailhouse Rock" top not only the U.S. and UK pop charts, but the U.S. country and R&B charts too, an unmatched feat.

March 1957
Elvis buys Graceland.

1957, live performances
Scotty Moore's Web site lists 20 gigs for the year.

March 24, 1958
Elvis is inducted into the U.S. Army and sent to Fort Hood, Texas, for basic training.

August 14, 1958
Gladys dies from heart failure, hepatitis, and cirrhosis of liver.

1960s

January 20, 1960
Elvis is promoted to sergeant of the 3rd Armored Division in Friedberg, Germany.

March 2, 1960
Elvis leaves Germany to return to civilian life in the U.S.

March 26, 1960
Elvis tapes *The Frank Sinatra Timex Show: Welcome Home Elvis* in Miami. It airs May 12.

1961, live performances
Two: February 25, Ellis Auditorium, Memphis; March 25, USS *Arizona* benefit at Pearl Harbor.

November 1962
When Elvis enters a Las Vegas casino surrounded by his entourage of 11 friends in mohair suits and shades, a journalist dubs them the Memphis Mafia.

April 6, 1965
Elvis releases "Crying in the Chapel" for Easter, an outtake from his 1960 gospel album. It reaches No. 1 in the UK and No. 3 in the U.S., his last Top 5 hit until "In the Ghetto."

February 16–17, 1966
Elvis begins rocking again with a new streamlined urgency for a few songs on the *Spinout* soundtrack, as he does in September for a few cuts on *Easy Come, Easy Go.*

May 25–June 12, 1966
Elvis records a remarkable collection of 21 spiritual and secular songs in Nashville with new producer Felton Jarvis, who he will work with for the rest of his life.

May 1, 1967
Elvis and Priscilla Beaulieu marry in Las Vegas.

February 1, 1968
Elvis and Priscilla's daughter Lisa Marie is born.

December 3, 1968
The *Elvis* NBC TV special airs at 9 p.m., and 42 percent of the TV audience tunes in.

January 13–February 22, 1969
Elvis records 33 songs at American Sound Studio in Memphis, for his albums *From Elvis in Memphis* and *From Memphis to Vegas*, and four singles, including "Suspicious Minds."

1969, live performances
Elvis returns to the stage at the International Hotel in Las Vegas on July 31 and gives 56 shows through August 28. Elvis's costume designer Bill Belew notes Elvis's measurements as chest 42 inches, waist 30 inches, height 5 feet 11½ inches, with a shoe size of 9.
(Source for live performances 1969–77: www.elvis-in-concert.com)

1970s

February 27, 1970
Elvis gives his first performance outside of Las Vegas at the Houston Astrodome in Texas. From now through 1976 he will alternate stints in Vegas with U.S. tours.

1970, live performances
137 shows.

August 28, 1971
The National Academy of Recording Arts and Sciences give the Bing Crosby Lifetime Achievement Award to Elvis.

1971, live performances
157 shows.

January 19, 1972
Highway 51 South in front of Graceland is renamed Elvis Presley Boulevard.

June 9–10, 1972
Elvis plays the Big Apple for the first time, selling out Madison Square Garden and earning rave reviews from the *New York Times.*

October 21, 1972
"Burning Love" makes it to No. 2 on the U.S. chart, his last Top 10 hit during his lifetime.

1972, live performances
165 shows.

January 14, 1973
Elvis gives the first global live concert performance for the special *Aloha from Hawaii,* viewed by as many as 1.5 billion people in approximately 40 countries.

October 9, 1973
Elvis's divorce from Priscilla is finalized.

1973, live performances
167 shows.

1974, live performances
158 shows.

July 19, 1975
Elvis plays piano in concert for the first time in Uniondale, New York, as he sings "You'll Never Walk Alone."

1975, live performances
107 shows.

1976, live performances
129 shows.

October 30, 1976
Elvis records "He'll Have to Go" in his last recording session at Graceland's Jungle Room.

August 16, 1977
Elvis dies at Graceland.

October 3, 1977
Elvis in Concert airs on CBS.

1977, live performances
55 shows. Elvis gives his last live performance on June 26, 1977, at the Indiana Market Square Arena in Indianapolis.

Where's Elvis?
Films & Music

Filmography
Elvis received good reviews from the *New York Times* and *Los Angeles Times* for his dramatic acting, but *King Creole, Flaming Star,* and *Wild in the Country* generated much less money at the box office than his musical comedies, so afterward he only made three more "serious" films: *Roustabout, Charro!,* and *Change of Habit.* His most financially successful films, in descending order, were *Viva Las Vegas, Blue Hawaii, G.I. Blues, Love Me Tender, Jailhouse Rock, Loving You, Girls! Girls! Girls!, Tickle Me, Roustabout,* and *Girl Happy.*
"No. 1" indicates both a U.S. and UK number-one record unless otherwise noted.
* = Film accompanied by a soundtrack album.
** = Film accompanied by an E.P. (extended play record).

Love Me Tender** 1956
Loving You* (No. 1 album) 1957
Jailhouse Rock ** (No. 1 E.P.) 1957
King Creole* (UK No. 1 album) 1958
G.I. Blues* (No. 1 album) 1960
Flaming Star** 1960
Wild in the Country 1961
Blue Hawaii* 1961
Follow That Dream** (UK No. 1 E.P.) 1962
Kid Galahad** (UK No. 1 E.P.) 1962
Girls! Girls! Girls!* 1962
It Happened at the World's Fair* 1963
Fun in Acapulco* 1963
Kissin' Cousins* 1964
Viva Las Vegas** 1964
Roustabout* (U.S. No. 1) 1964
Girl Happy* 1965
Tickle Me** 1965
Harum Scarum* 1965
Frankie and Johnny* 1966
Paradise, Hawaiian Style* 1966
Spinout* 1966
Easy Come, Easy Go** (UK No. 1 E.P.) 1967
Double Trouble* 1967
Clambake* 1967
Stay Away, Joe 1968
Speedway* 1968
Live a Little, Love a Little 1968
Charro! 1969
The Trouble with Girls 1969
Change of Habit 1969
Elvis: That's the Way It Is* 1970
Elvis on Tour (Golden Globe Award for Best
 Documentary) 1972

Discography
Elvis came of age before the era of album-oriented rock and primarily viewed himself as a singles artist. Yet, he also recorded dozens of great album tracks—many compiled in three *Essential Masters* box sets (and gospel/soundtrack sets), though not all his best movie or 1970s songs are included. Visit www.facebook.com/whereselvisbook for more playlists. "No. 1" indicates both a U.S. and UK number-one record unless otherwise noted.

ALBUMS
Elvis Presley (No. 1) 1956
Elvis (U.S. No. 1) 1956
Million Dollar Quartet 1956
Elvis's Christmas Album (U.S. No. 1) 1957
Elvis Is Back! (UK No. 1) 1960
His Hand in Mine 1960
Something for Everybody (U.S. No. 1) 1961
Pot Luck (UK No. 1) 1962
Elvis for Everyone 1965
How Great Thou Art 1967
Elvis (NBC TV Special) 1968
From Elvis in Memphis (UK No. 1) 1969
From Memphis to Vegas / From Vegas
 to Memphis 1969
On Stage 1970
Elvis Country (I'm 10,000 Years Old) 1971
Love Letters from Elvis 1971
Elvis Sings the Wonderful World of
 Christmas 1971
Elvis Now 1972
He Touched Me 1972
Elvis: as Recorded at Madison
 Square Garden 1972
Aloha from Hawaii via Satellite (No. 1) 1973
Elvis .. 1973
Raised on Rock 1973
Good Times 1974
Elvis: as Recorded Live on Stage
 in Memphis 1974
Elvis: a Legendary Performer
 Volume 1 (U.S. No. 1) 1974
Promised Land 1975
Today 1975
From Elvis Presley Boulevard,
 Memphis, Tennessee 1976
Elvis: a Legendary Performer
 Volume 2 (UK No. 1) 1976
Moody Blue 1977

SINGLES

"No. 1" indicates both a U.S. and UK number-one record unless otherwise noted.
b/w = backed with (B-side).
E.P. = Extended play record.

That's All Right b/w Blue Moon of Kentucky ... 1954
Good Rockin' Tonight b/w I Don't Care If the Sun Don't Shine 1954
Milkcow Blues Boogie b/w You're a Heartbreaker 1954
Baby Let's Play House b/w I'm Left, You're Right, She's Gone 1955
I Forgot to Remember to Forget b/w Mystery Train 1955
Heartbreak Hotel (U.S. No. 1) b/w I Was the One 1956
I Want You, I Need You, I Love You (U.S. No. 1)
 b/w My Baby Left Me ... 1956
Don't Be Cruel (No. 1 on all U.S. charts: pop, country, R&B)
 b/w Hound Dog ... 1956
Shake, Rattle and Roll b/w Lawdy Miss Clawdy 1956
Love Me Tender (U.S. No. 1) b/w Any Way You Want Me 1956
Blue Suede Shoes b/w Tutti Frutti, Love Me (E.P.) 1956
Too Much (U.S. No. 1) b/w Playing for Keeps 1957
All Shook Up (No. 1) b/w That's When Your Heartaches Begin 1957
Peace in the Valley (E.P.) ... 1957
(Let Me Be Your) Teddy Bear (U.S. No. 1 pop, country, R&B)
 b/w Loving You .. 1957
Party b/w Got a Lot o' Livin' to Do (UK only) 1957
Jailhouse Rock (UK No. 1, U.S. No. 1 pop, country, R&B)
 b/w Treat Me Nice .. 1957
Don't (U.S. No. 1) b/w I Beg of You .. 1958
Wear My Ring Around Your Neck b/w Doncha' Think It's Time 1958
Hard Headed Woman (U.S. No. 1) b/w Don't Ask Me Why 1958
One Night (UK No. 1) b/w I Got Stung .. 1958
(Now and Then There's) A Fool Such as I (UK No. 1)
 b/w I Need Your Love Tonight .. 1959
A Big Hunk o' Love (U.S. No. 1) b/w My Wish Came True 1959
Stuck on You (U.S. No. 1) b/w Fame and Fortune 1960
It's Now or Never (No. 1) b/w A Mess of Blues 1960
Are You Lonesome Tonight? (No. 1) b/w I Gotta Know 1960
Surrender (No. 1) b/w Lonely Man ... 1961
Wooden Heart (UK only No. 1) b/w Tonight Is So Right for Love 1961
I Feel So Bad b/w Wild in the Country .. 1961
(Marie's the Name) His Latest Flame (UK No. 1) b/w Little Sister ... 1961
Can't Help Falling in Love (UK No. 1) b/w Rock-a-Hula Baby 1961
Good Luck Charm (No. 1) b/w Anything That's Part of You 1962
She's Not You (UK No. 1) b/w Just Tell Her Jim Said Hello 1962
Return to Sender (UK No. 1) b/w Where Do You Come From 1962
One Broken Heart for Sale b/w They Remind Me Too Much of You ... 1963
(You're the) Devil in Disguise (UK No. 1) b/w Please Don't
 Drag That String Around .. 1963
Bossa Nova Baby b/w Witchcraft ... 1963
Kissin' Cousins b/w It Hurts Me ... 1964
Kiss Me Quick b/w Suspicion ... 1964
What'd I Say b/w Viva Las Vegas .. 1964
Ask Me b/w Ain't That Loving You Baby .. 1964
Such a Night b/w Never Ending .. 1964
Do the Clam b/w You'll Be Gone ... 1965
Crying in the Chapel (UK No. 1) b/w I Believe in the Man in the Sky 1965
(Such an) Easy Question b/w It Feels So Right 1965
I'm Yours b/w (It's a) Long Lonely Highway 1965

Puppet on a String b/w Wooden Heart .. 1965
Tell Me Why b/w Blue River .. 1966
Frankie and Johnny b/w Please Don't Stop Loving Me 1966
Love Letters b/w Come What May ... 1966
Spinout b/w All That I Am ... 1966
If Every Day Was Like Christmas b/w How Would You Like to Be 1966
Indescribably Blue b/w Fools Fall in Love .. 1967
You Gotta Stop b/w The Love Machine (UK only) 1967
Long Legged Girl b/w That's Someone You Never Forget 1967
There's Always Me b/w Judy ... 1967
Big Boss Man b/w You Don't Know Me .. 1967
Guitar Man b/w High Heel Sneakers ... 1968
U.S. Male b/w Stay Away .. 1968
You'll Never Walk Alone b/w We Call on Him 1968
Let Yourself Go b/w Your Time Hasn't Come Yet Baby 1968
A Little Less Conversation (UK No. 1 when remixed in
 2002 by Junkie XL) b/w Almost in Love ... 1968
If I Can Dream b/w Edge of Reality ... 1968
Memories b/w Charro .. 1969
In the Ghetto b/w Any Day Now ... 1969
Clean Up Your Own Backyard b/w The Fair Is Moving On 1969
Suspicious Minds (U.S. No. 1) b/w You'll Think of Me 1969
Don't Cry Daddy b/w Rubberneckin' ... 1969
Kentucky Rain b/w My Little Friend .. 1970
The Wonder of You (UK No. 1) b/w Mama Liked the Roses 1970
I've Lost You b/w The Next Step Is Love ... 1970
You Don't Have to Say You Love Me b/w Patch It Up 1970
I Really Don't Want to Know b/w There Goes My Everything 1970
Where Did They Go, Lord b/w Rags to Riches 1971
Life b/w Only Believe ... 1971
I'm Leavin' b/w Heart of Rome ... 1971
It's Only Love b/w The Sound of Your Cry 1971
I Just Can't Help Believin' b/w How the Web Was Woven (UK only) 1971
Until It's Time for You to Go b/w We Can Make the Morning 1972
He Touched Me b/w Bosom of Abraham ... 1972
An American Trilogy b/w The First Time Ever I Saw Your Face 1972
Burning Love b/w It's a Matter of Time ... 1972
Separate Ways b/w Always on My Mind .. 1972
Steamroller Blues b/w Fool .. 1973
Raised on Rock b/w For Ol' Times Sake ... 1973
Polk Salad Annie b/w See See Rider (UK only) 1973
I've Got a Thing About You Baby b/w Take Good Care of Her 1974
If You Talk in Your Sleep b/w Help Me .. 1974
Promised Land b/w It's Midnight ... 1974
My Boy b/w Thinking About You ... 1975
T-R-O-U-B-L-E b/w Mr. Songman .. 1975
Bringing It Back b/w Pieces of My Life .. 1975
Hurt b/w For the Heart ... 1976
Moody Blue b/w She Thinks I Still Care .. 1976
Way Down (UK No. 1) b/w Pledging My Love 1977
My Way b/w America the Beautiful .. 1977
Unchained Melody b/w Softly as I Leave You 1978

Where's Elvis?

Index

Acknowledgments

Many thanks to Emma Bastow, Jo Turner, and Ellie Wilson for giving me the chance to work on another book about one of my favorite musical artists. Thanks to Victor Beuren for bringing all the people and places to life in his gorgeous illustrations, and to art director Michael Charles and designer Allen Boe for creating such a beautifully designed book. It has been a pleasure to work with project editor Cheryl Brown as she painstakingly assembled all the elements. As always, thanks to my agent Charlie Viney and Sally Fricker of the Viney Agency. Thanks to Jeff McCarty for arguing with me about music over margaritas. Thanks to my Mom for bringing home an Elvis record when I was seven years old, and for not complaining as I proceeded to play "Don't Be Cruel" over and over again for the rest of the evening. And I am glad to see Elvis alive and well in one of my daughter Keira's favorite Disney movies, Lilo and Stitch.